The Great Clivette

Renaissance Man, Artist, Magician, Acrobat,
Shadowgraphist, Mindreader, and so much more.

Michael David MacBride

ISBN: 979-8-9879393-0-7

Library of Congress Catalog Card Number 2023904519

DEDICATION

To all the people who have slipped through the cracks of history.

CONTENTS

LIST OF IMAGES

* All dimensions are in inches

ACKNOWLEDGMENTS

Thank you to Clivette Estate—Chris and Jason Lieber especially—for your invaluable help, assistance, patience, and willingness to help me with this project. It truly would not have been possible without you.

Thanks to Gayle, Dylan, and Parker, for tolerating me always prattling on about this project and disappearing for hours at the keyboard.

Thanks to Heidi Wall Burns for being editor, collaborator, and friend. I always appreciate your perspective and my writing is always the better for it.

Thanks to all my friends who listened to the story, poked holes in it, and asked questions that made this project better.

NOTE TO THE READER

The Clivette estate and I have collaborated to be as historically accurate about Merton Clivette's life as possible in the pages that follow. Unfortunately, records are incomplete. There are gaps in the history books, and the people who lived during that time all have passed. What follows is the best biography we can muster from the documents and research available to us. Because it's written in the style of an autobiography, we've used terms that were appropriate to the time, but might be deemed offensive now. For instance, "Indian" is a label that is reductive, inaccurate, and doesn't address the diversity and many cultures and tribes that predate European arrival. At the end of the book, you'll find a "Fact from Fiction" section that provides "just the facts." It's broken down according to the different parts of Clivette's life. Our hope is to provide two different ways to get to know and understand this fascinating man.

INTRODUCTION

They called me the Great Clivette. Well, truly, in all transparency and honesty I gave myself that name. I mean, they did call me that, but only after I put it on posters and declared it to be true. The trick, which proved easy, was to make myself and my act worthy of the label. They also called me the Man in Black. Again, I gave myself that name, but eventually, it also caught on. I was born Merton Clive Cook in 1848 in the middle of the Indian Ocean. Or was I born in Wisconsin? In 1868? See, I made my living being larger than life, entertaining crowds, and performing. Telling stories. Making audiences laugh and sharing tales of my world travels. Now, all these years later, after telling those stories so many times, it's hard for me to remember which are true and which are not. A fabrication, or maybe exaggeration is a better word, told again and again lodges itself in your brain and becomes truth after a while. Add old age to the equation, and it all is very tricky to navigate.

Here's the thing: a crowd doesn't want to hear about a little boy named Merton Cook born in Wisconsin; they want the Man in Black. Mysterious. Full of wonder. A newspaper doesn't write a story because a boy's father dies, and his mother moves him to the Wyoming Territory. Or, at least they don't until you make a name for yourself as The Great Clivette. Then the papers want to know, who is this person? Where did he come from? And can

his story sell us papers? The problem is, then, your whole livelihood is wrapped up in these stories. The splash and spectacle are far more enticing than the mundane truth.

So here it is: my life account. I'm setting the record straight before I'm not around to do it anymore. What can you expect? Well, much of the stories you've heard are true. I did cross the Atlantic multiple times (though maybe not 32 times). I knew Buffalo Bill, Harry Houdini, Mark Twain, and PT Barnum. Did I almost broker a deal to move Shakespeare's house to Long Island? Maybe. Did I teach Sir Arthur Conan Doyle the dark arts? Yes, and that hack has been ripping me off ever since. Did I perform for Queen Victoria, King Edward, Lord Kitchener? Did I study art and sculpture under Auguste Rodin? Could I speak nine languages? Yes.

Was I the greatest shadowgraphist, silhouettist, mind-reader, equilibrist, phrenologist, magician, illusionist, pantomimist, necromancer, umbramanist, slack- (and tight-) rope walker, hypnotist, juggler, prestidigitator, and painter of all time?

I tend to think so. But read on and judge for yourself.

THE EARLY DAYS

Regardless of what I've done as a career, I've always been a storyteller. People have always said, "You should write this down!" and eventually I did. In fact, I wrote many books, but somehow the autobiography never really came together. The closest I got was in my book *Café Cackle from Dumps to Delmonico's* (1909). It's really a story about stories from restaurants in different cities around the world. Some are borderline restaurant reviews, and others are more about the people I met and the conversations we had. Of all the books, it's the one that came closest to being my "true story." At least it started that way. Here's a little bit from the introduction:

"I well remember, as a boy, how I detested anything that had a semblance of work—in fact, I was born tired. My delight as a child was to crawl out on the roof of the old oak house and watch the sun peep over the hills and bathe the landscape with scintillating beauty. As the air became warm, I would crawl down to the old apple tree beside the roof and linger in the shady branches and listen to the birds sing. At this early age, I conceived the idea that life means but little unless one does as one pleases. The thoughts of labor always had a peculiar effect on my sensitive temperament. At times I would become morbid thinking of it and would drown my sorrow with anything luscious I could get hold of. In fact, it didn't seem to matter whether it belonged to me or not."

Do I have to cite myself? Without a citation, will I be accused

of plagiarism? Okay, just to be safe, that's from pages 9 through 10. I cut out a bit in between, just to clean it up, because age is the best editor. You look at things with a more experienced eye and can cut the fat that a younger version of yourself might have left there.

Why include something I've already published in this new book? Well, my hope is that it gives you a taste of who I was. The kinds of things that occurred to me, even as a young boy. And the things that stuck with me as I grew older. Just what are those "things"? The beauty of nature. The art that surrounds us on a regular basis. Finding meaning in life instead of simply being content to see what life throws my way. I was always on the prowl for something to entertain me, or for some angle. The forty-one-year-old version of myself once wrote, "I detested anything that had a semblance of work," but I can honestly say that isn't true. I detested "work" that didn't bring me joy. That didn't challenge me. That didn't teach me something. That didn't offer some kind of fulfillment. No, I never was going to be a typesetter for the sake of setting type, but I would work at a newspaper to be the first to read the news and to help spread the stories. It really wasn't about the work; it was more about how I framed it to myself. Once I fell into the idea that I could make a living doing acrobatics, or magic, or painting, I loved working.

Okay, but before we get to all of that, let's go back to the beginning. The real beginning.

Here's the thing. In 1868, Wisconsin was way different from the way it is today. Heck, the United States was way different. We didn't even have a vice president. Andrew Johnson had taken over when Lincoln was assassinated, and there wasn't a formal process to appoint or assign a new vice president, so he didn't. Johnson also made history by being the first president to be impeached, though he was ultimately acquitted. That whole thing was resolved before I was born. When I came into the world, Wisconsin had been a state for twenty years. The big industries were logging and brewing. It wasn't until the 1890s that

Wisconsin would shift to dairy and become known for its cheese. This is all stuff I learned later in life. As a kid, I just knew this was the place we lived.

For that matter, as a kid, I really knew very little about my family history. Now that they're gone, I still don't know very much. It's funny how you take for granted the people around you and forget that they have a past and a history all their own. I know Dad was born in New York in 1824, and Mom was a Canadian born in 1835. I never knew, and still don't know, the story of how they met. What attracted them to one another? How long did they date? Did they have a long engagement? How did their parents feel about the eleven-year age gap? My mother was sixteen when my oldest brother was born.

For the record, here's the birth order. I was the youngest of: Frank (1851), Eva (1854), Ernest (1857), and Eugene (1865). Dad died when I was six, so I really don't remember him much. I'm not convinced that what do remember are even real memories. They could be stories I've been told enough times to make into memories. We had one daguerreotype of Dad, and I remember as a kid, staring at that image to remember him. If I close my eyes now, I can still see his face. Is that a memory? Mom always said he was a retired British sea captain, but I also know he was born in New York. Was he British? He definitely served in some capacity at sea, but whether that was the British or American Navy, I don't know.

Two years after Dad died, Mom moved us to the Wyoming territory. Why Wyoming? Hard to say. Mom was more interested in working in the newspapers than politics, but maybe the fact that women had the right to vote in Wyoming encouraged her that it would be a good place for women to work, too. At any rate, this is what she did. She moved us all to Wyoming and started working at a newspaper—and I would follow this profession later in life.

When I was ten or eleven, I printed a card for myself that read, "The Rocky Mountain Kid, Typographical Tourist." I would show this card to people but never give to them. I only had the

one card. It was my way of flashing a badge, of sorts, to indicate I knew my way around a typesetting machine. For a kid, typesetting was an easy way to make some money. And I was good at it. I even participated in typesetting contests. The adults always assumed their years of experience would ensure victory, but I don't think I ever lost a contest. Some of the contests were just for honor and bragging rights, but others had a cash prize or people betting on the outcome.

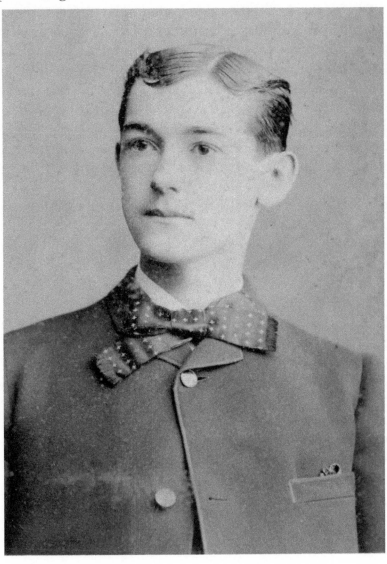

I remember my mom clearly. She was always busy, always working. People would say she just wanted to provide for her family since her husband had died, but I can't help but think my dad's death liberated her. She poured herself into newspapers. She read and was active in the community, and then one day she just up and left. She abandoned us. Frank was thirty, Eva was twenty-five, Ernest was twenty-three, Eugene was fifteen, and I was twelve.

Why'd she leave? Good question. The short answer: She joined the Seventh-Day Adventists. It was a relatively new church at the time, only officially becoming a formal organization in 1863. By 1880, sometime after she abandoned us, the church was a little more established. Mom had worked her way up into a position with the church that suited her, and she took it. She always had lofty aspirations, and I think she figured: my children are grown enough, my husband's gone, and I want this. There simply wasn't room in her vision for us. Remarkably, she never married again (didn't seem to have any interest in having a man tell her what to do) and instead kept moving west until she got to Los Angeles. She could have taken us with her, but instead she left us to make our own way and blaze our own paths. So, I guess in pursuing her own liberation, she freed us in a way, too.

After Mom left, I stayed around Wyoming for two more years under the care of my older siblings, but then I ran away to join the circus. The world of "print" in Wyoming was too small to contain me, and I wanted to see the world. Eva eventually got married and lived the rest of her life in Wisconsin. By 1899 she was dead. Frank got married and moved out of Wyoming down to Utah. He died in 1916. Ernest eventually made his way west and died there in 1920. I think Eugene is still living, but I haven't been able to connect with him. As for me . . . my life was just getting started.

BUFFALO BILL

I said I ran away and joined the circus, but was Buffalo Bill's Wild West Show a circus? I guess people debate this. The Wild West Show toured the United States, England, and Europe. They used tents, included animals, and entertained audiences with marvelous feats. It sounds like a circus to me. If you were to ask Buffalo Bill Cody or PT Barnum, I think each would be offended. Cody would object because he thought the Wild West Show was serious entertainment. A recreation of the West. Educational. And PT Barnum would object to calling the Wild West show a circus because it lacked the pillars of the circus: Clowns and elephants.

Regardless, I ran away from home and joined the Wild West Show one day when it came to my town, I saw an opportunity, and I went for it. Slight correction, just for the sake of accuracy: I didn't join the Wild West Show, because it wasn't named that until 1883; I joined Buffalo Bill's Combination (sometimes called an Acting Troop or Troupe and other times called Theatrical Troupe).

I don't remember the exact date that I joined the group. I started to keep meticulous notes and ledgers much later in life, but who does that kind of thing when they're ten or eleven or twelve? I did keep artifacts from the performances—flyers and newspaper clippings and that kind of thing—but I didn't have a

running diary of dates. The Wild West Show came through my town in late July and August of 1879. Mom had already left to join her own circus of sorts. Frank and Eva did their best to provide a good life for me, but they had their own lives to live and figure out.

By 1879, Wyoming was still eleven years from being a state. Not that statehood would have kept me from joining Buffalo Bill, but you have to remember, this was a time when everything was in flux. If you're not a state, you don't have the full support of the federal government. Things were a bit looser and freer. For a kid, like me, with a dead father and a mother who had run away and two older siblings doing their best to figure out how to be adults, it meant I was freer, too.

Before the Wild West Show came to town, I was already familiar with the stories of Buffalo Bill. I had heard about the tricks he could pull off with a rifle and a horse, and I practiced them. I was living in the west. Indians were a reality of my world. For people out east, I'm sure the Wild West Show was little more than entertainment, but for me, on the frontier, in this weird no-man's-land, Cody's skills were practical ones that I thought I needed to survive. I knew that a bandit would not be impressed if I could jump on and off a galloping horse, a bear would not care if I could shoot a bottle blindfolded, and a rattlesnake would not care if I could throw a knife into a target at twenty-five yards. Even at a young age, I knew those were tricks for the show. But, I thought if I could do those things, if I could truly master the rifle and horse and knife, then I could survive in this wild territory my mom had moved us to.

Cody was constantly picking up new people and losing people along the way. Most famously he added Annie Oakley and Sitting Bull, but most of the people in the show weren't the big names. They were people like me who nonchalantly forced our way in. I didn't have money to see the show, so I was nosing around when they were setting up. One of the staging hands saw me and asked if I wanted to feed the horses some carrots. He sensed immediately how natural I was with the animals and asked if I

could ride. I said yes. The next thing I knew, I was doing tricks for him, and then a couple more people.

The attention in the show was mainly on the cowboys, trick riders, and big names, but the Indians were just as important. They had some real Indians that had joined the show, but, unfortunately, they didn't have enough Indians for all the acts and scenes they wanted to recreate. That's where someone like me came in. With a little make-up and a costume, suddenly I was a young brave. I rode naturally enough and could shoot and throw knives, and that's all they needed. As I spent more time with the show, I learned how to trick ride, you know, like jumping on and off the horse mid-gallop. I already knew how to ride bareback, but I learned how to shoot from the saddle. Rifle, pistol, and bow. Because I was young, I picked it up easy enough. I also spent time with the Indians and learned how they spoke, and they told me stories that I remember to this day.

So many of them were just trying to make a living and figure out how to survive in the changing times. With us whites moving in and budging them out of the land, they needed to do something, but being part of the show made them feel like traitors. Some said they were being exploited and others felt like sellouts. The show traveled around the country, and they were away from their families for a long time. Very few traveled with their families. Since I was just a kid with no family, the Indians kind of adopted me. Every night we performed together and after the show, we spent time together. On stage, we were a family around a teepee or as part of a raid, and after the show, we were a family sitting around a fire or traveling on the train.

Sometimes I'd even sketch them. Drawing was something I used to do. People always said I had a knack for it. I didn't really understand the big deal around my little sketches; I saw something and made my pen or pencil draw what I saw. For someone like me, for whom drawing came naturally, it took me a while to understand it wasn't something everyone could do. Before long, I was drawing portraits for people and even selling a couple sketches here and there. Sadly, I didn't keep any of the

drawings or really any artifacts from that time. It didn't occur to me, and even if I had wanted to, I didn't have the means to save or store anything. Our accommodations were small, and we were built to be light on our feet. Only the essentials. I'll also add, who thinks about keeping things like that when they're a kid? I certainly didn't.

Beyond earning money and gaining a sort of family for a while, the Wild West Show taught me two valuable lessons that would serve me for the rest of my life.

First, a little make-up goes a long way. I was a kid from Wisconsin, but with a little make-up and a costume, I was transformed into an Indian. No one questioned it. Even after the show, when people would find their way back to our wagons or train cars, I was an Indian brave to them. As long as I could stay in character, and commit to playing my part, sometimes simply by saying nothing and remaining mute, they'd believe. It was a powerful lesson in how easy it is to reinvent yourself, and the power of suggestion—from make-up, and costumes, and renaming yourself.

Second, sometimes there simply isn't a "trick;" it's just a willingness to do something that others are not. I'm getting ahead of myself a little, but often in the circus there's someone who swallows swords. Everyone always asks, "What's the trick?" And the trick is, there is no trick. You just learn how relax your throat muscles and do it. Doesn't that hurt? Sure, sometimes you get cut. But the paycheck and attention are worth the risk. The same was the case in the Wild West Show. We did things at every performance that could have gotten us killed. There was no trick to the things we did with horses. We practiced and got good at it, or we got hurt. Sometimes we got hurt while we were practicing. Sometimes horses had to be put down. When they were shooting at us, or throwing knives, sometimes we got hit. I still have pellets in my back and scars to show for it. The best way to sell a trick as being real, is for it to be real. Do the thing as safely as you can, but still just actually do it. Some people can commit to that, and others can't. I learned I was one who could commit to it. And so

I did it. I didn't do it halfway, or I would get hurt. The sting of a rifle ball passes, a knife wound heals, and I bounced back from sprains and twists from stepping wrong getting on or off a horse. The minute I started to doubt myself though, that's when trouble really set in. If I had thought I couldn't do it, I would have been right, but I never doubted. I always thought I could, and I ended up with over two hundred bullet and knife wounds in my back. Just imagine if I wasn't so confident.

So to answer the question everyone asks: Did I meet Buffalo Bill? Short answer: Yes.

Longer answer: Everyone in the troupe, or troop, or whatever you want to call it, did. He made his rounds and knew all his performers. I think there was a particular soft spot for me because we shared so much in common. We both lost our fathers early, his when he was eleven and me when I was six. We both lost our mothers young, too; his mom died when he was sixteen or seventeen, and mine ran off when I was twelve. That's why we kept in touch, even after I left. I don't mean to imply we were best friends, but that circle of entertainers, people in the circus, or Wild West Show, or vaudeville was pretty small. You would have to really not like someone and be lucky, to avoid crossing paths again. Thankfully, Buffalo Bill liked me.

That's why, later, when PT Barnum joined forces with James A Bailey to create, "The Greatest Show on Earth," Bill turned to me and said, "Well, I guess if it's the Greatest, you should see what all the hubbub is about. You can be my little spy." I had been itching to do something other than ride horses and do tricks with guns and knives, and he knew it. "Don't you worry," he said. "There's always a place for you here. But go off and try being an acrobat or do something really dangerous."

THE CIRCUS

I have always been very good at observing others and fitting in and am still surprised that it doesn't come naturally to everyone. I learned early in life that confidence goes a long way. If you act like you belong, then you belong. It worked for me with Buffalo Bill, and it served me well later in life, too. Some people are too tentative or hesitant. I can't tell you how many people I have met who wanted to be a writer, or a painter, or whatever, but none of them could find a way forward. They all wanted to know what the secret was. The secret, it turns out, is that there is no secret. You just start telling people you are a writer or a painter. The biggest trick is to convince yourself that you are one and then believe what you have told yourself, and then actually commit to it.

Back in the day, the circus was a big deal. Once the posters started going up, everyone knew it was just a matter of time before the trains would roll in with tents, animals, and performers. The excitement was palpable. It was such a production. In fact, some of the smaller towns would almost double in population when the circus people were in town.

If you wanted to join the circus, it was easy to do. There were so many moving pieces and people. I don't know that anyone actually knew who did and didn't belong. If you wanted to join, you just walked over and joined in the work. At the end of the

day, you hopped on the train and that was that. Now, if you wanted to get paid, that was another thing. They might not have kept a roster of names for who worked for the circus, but they definitely kept a tight eye on who they paid. If you wanted to join *and* get paid, then you had to make yourself really useful. Act like you belonged. Do the work. Be noticed.

In my time with the circus, I watched a bunch of kids join the circus. The ones who were most successful joined-up when the circus was being torn down. All the glamor of the circus was over, and now it was just hard work and waiting. The ones who showed up when we were setting up were often there to catch a free show. The kids who showed up after, the ones who helped roll tents and lug equipment to load on the train, those were the ones who fit in the best. And when asked, the smart ones didn't say, "Oh I joined at the last stop," they said, "I've been with you since Kansas City" (and Kansas City was three or four stops previous). They did enough research to know the itinerary and picked a stop that was reasonable but long enough ago that it was plausible they had been overlooked.

I didn't have to do any of that.

The night before I left Buffalo Bill and the Wild West Show, he pulled me aside and we had a little talk.

"Listen," Cody said. "Don't call him Barnum, or PT, or Mr. Barnum, or any of that. His friends call him Taylor. And you're one of his friends."

"I am?" I asked.

"You are," Cody said. "I know him well enough. Not really friends, but we basically do the same thing. A lot in common. I wired him to let him know you're coming. All you have to do is walk in to his train car or tent or wherever he'll be and talk to him as though he's been waiting for you." Cody twisted the end of his mustache smiling. "If you can't find him, just ask for Taylor, and people will point you in the right direction."

I arrived at the circus and waited for the right opportunity to present itself, a chance to catch Taylor's eye in passing or to run

into him outside his door nonchalantly, but the opportunity never arrived. All the while, a saying my dad used to say to me ricocheted around my mind: "You have to make your own luck." After a few hours of stupidly waiting for luck to fall across my path, I decided to make my own luck. I walked up to his trailer, knocked on his door, and walked in like I belonged there.

"Yes?" Taylor asked, looking at me cooly.

"Cody sent me," I said.

"Oh?"

I wasn't really sure what to say next, so I waited.

"As some kind of spy?" Taylor asked.

"No," I said. "I did my time with Cody's show and learned all I can from him. Now I want to do what you do."

"And just what do I do?"

"Travel the country; put on the greatest show on Earth," I said. "Create wonder."

"It does sound nice when you put it that way," Taylor said. "And who are you?"

"Merton."

"What kind of name is Merton?"

"The one my parents gave me," I paused for a moment, trying to remember what my mother had told me. "I think my mother said it means town by the lake."

"Town by the lake," said Taylor. He laughed a little. "And which town would that be?"

"I'm not sure. We lived in Milwaukee for a while, so maybe the lake is Lake Michigan?"

"I asked about the town, not the lake," said Taylor. "But, no bother. Never tell anyone you were born there. There's not much mystery in Milwaukee. Or Wisconsin. Or Lake Michigan."

I waited for him to go on, and after a moment he continued.

"I believe you're going to be my little French man," said Taylor. "You've heard of General Tom?"

"No."

"General Tom Thumb?"

"No."

"Little Tom Thumb?"

"No."

"My, my, you really are green, my boy."

Taylor rubbed his chin and thought, and I waited patiently.

"Okay," he said finally. "What can you do? What's your trick? What do you bring to the circus?"

"I can ride a horse," I said, then quickly added, "trick-ride a horse. On and off, doing somersaults, and flips. Handstands in the saddle."

Taylor shrugged. "Okay. Is there more?"

"I know how to fight and catch arrows and bullets from the air. And I can do trick shots with the bow and rifle or gun."

"That's promising," said Taylor. "Though, guns might spook the animals. How are you with heights?"

"They don't bother me."

"The Little Frenchman without fear," he said. "This could work. Can you read?"

"Yes." I may not have finished school proper, but Mom made sure I could read. I hated that she made me set aside time each day to practice and to read to her, Eventually I learned there isn't a lot to do after dark, but adventure awaited for those who could read by the light of a dim lamp or the fire. I started to read a lot. I absorbed knowledge from the books I read. It molded me into the person I was to become. When people met me, they often assumed I was older than I was or they described me as an "old soul" or something similar.

Taylor leaned back in his chair and then suddenly spun around, got up, and walked to a bookcase. After thumbing through several books, he returned with three in his hand. "You want to learn from me, start by reading these."

The titles read: *The Life of P. T. Barnum: Written by Himself, Struggles and Triumphs, or Forty Years' Recollections of P. T. Barnum,* and *Art of Money Getting, or, Golden Rules for Making Money.*

"There's a second part of *Struggles* coming soon, and another book maybe next year. I have those drafts back here. If you finish these and want to learn more, I'll share those with you. But read

those first. They will give you an idea of what you're in for if you join up with me. If you're still interested, we'll figure out your act."

"Thank you," I said and quickly added, "Taylor."

He nodded and I went to study.

After I had read about his "early life" in the first book, I began to notice the differences in the way he told the story in the subsequent books. Hardships and accomplishments were amplified in the later versions. I know that memory distorts over time, but knowing Taylor the little bit I did, I guessed this amplification wasn't an accident. When I was done, I returned to his car.

"Okay," I said. "I think I got it."

"Got what?" he asked.

"How I can become your little French man."

"Tell me."

"Well, obviously my last name, Cook, won't work. But Clivette would. So, I'm Merton Clivette. French, but born on the Indian Ocean aboard a sailing ship. Maybe called the *S.S. Enterprise*?"

"Why the Indian Ocean?"

I was surprised he didn't ask about the *S.S Enterprise*, but maybe he just didn't know. I had read about it an old paper I found. These days, people throw the paper away when they're done. Or they burn it. But reading materials were rare in the West. We didn't have the libraries they did in the East. A lot of the smaller towns kept their old papers, and this became their version of a library, just a collection of papers and magazines and occasionally a book or two that people had donated or left behind. When I had time to read, I liked to flip through the papers and find something from the past to read about. It's how I read about the *S.S. Enterprise* and knew it was the first steamship to travel to India. It left England, but it was feasible that someone from France would travel to England to take a steamship to India. I was prepared to tell Taylor all of this, but he didn't ask. He threw me for a curve by asking about the Indian Ocean.

"India is mystical," I said. "Unlike Wisconsin."

"And the ocean?" Taylor asked.

"Being born at sea is exotic," I said. "Which country claims you when you're born at sea? I really don't know, but it adds to the mystique."

Taylor nodded.

"I'll grow a mustache. That way I'll seem older. Instead of being born in 1868, I'll say I was born twenty years earlier."

"Good," said Taylor. He was smiling. "And your act?"

"Anything you throw my way," I said confidently.

"I like it," said Taylor. "Let me think on this. We'll work you in and see how it goes. But I don't want to overcommit until I see how it goes."

That's how it went. I juggled knives. I threw and caught knives. I did the tightrope act, then the slack wire act. Then trapeze and acrobat. Sometimes I filled in for the contortionist. In short, I was Taylor's utility man. Sometimes, I was pretty sure he just wanted to see where my line was and if there was something I wasn't willing to or couldn't, do. But he never found it. Anything he threw my way, I was either naturally talented at or I figured it out quickly.

Lately, when I talk about my circus days, I find people don't know what a slack wire act is. This is sad. Somehow the tightrope act has taken all the fame and attention, due to people like Charles Blondin and his crossing Niagara Falls, or Pablo Fanque, and others like them. I think tightrope walking captures the imagination more because of the heights and perceived danger, but it's just playing on a common fear of heights. I've done both slack wire and tightrope and let me tell you slack wire is far more unpredictable. The slack wire moves and sways in a way a tightrope does not, and it requires total control of your muscles and balance. When you're walking on the slackline, you are constantly swinging and moving the rope and counterbalancing your body in the other direction.

Okay, while I'm digressing, let me put to rest the question I am asked the most, once and for all: No, I did not help or try to broker a deal for Shakespeare's home to be moved to New York.

It is 100 percent true that Taylor wanted Shakespeare's house, but I had nothing to do with it. That was another "trusty agent" (as Taylor referred to us). That agent was sent under the strictest confidence to bid on the property without letting anyone know who was behind the money. Unfortunately, somehow, the English got wind of Taylor's bid. Before the talks could get serious, Charles Dickens and others stepped in and ensured Shakespeare's home would never leave England. They paid $3,000 for that privilege. This all happened around 1847—I think—long before I was born. Predictably, when we needed some press coverage, Taylor would bring the matter of the house up again. So, yes, I did once send a letter inquiring if the house was for sale, but we knew the answer. We knew the outrage would prompt some press, and that press would drive ticket sales. And it almost always worked. Sometimes we wouldn't even have to send a letter; we could just leak to the press that Taylor was putting together a bid, and they'd jump all over it.

Perhaps there's one more question I get asked more than that: How many bones have I broken. As you can probably guess, injuries aren't uncommon for folks in my line of work, but they are not as frequent as you'd expect. I have fallen from heights before, but you learn how to take a fall. The better shape your body is in and the more prepared you are, the better you can roll out of a fall or use your natural shock absorbers to prevent broken bones. Because falling is a reality of the trade, you learn how to do it better. More often the injuries are ones you're not expecting and can't prepare for, like closing a cage door and not moving your fingers fast enough, or hammering in tent stakes and missing the mark, or getting too lost in thought as you walk through an area where someone else is practicing their act.

When asked the question about broken bones, I'm never sure if the person wants there to be many or few. I've answered both ways. "Oh, so many I can't count. But you know when a bone heals, it heals stronger than before so I'm nearly invincible now!" That's one response that usually gets a chuckle. When I've said "never," people seem disappointed but maybe also a little in awe

that such a thing is possible. In the end, the truth is that I broke a pinkie finger closing a cage door and broke a toe when I tripped over something—I still don't know what.

The circus was a fun time for me. I absorbed everything I possibly could. I didn't know what would be useful in the future, and I didn't really know what my future held. I had a sense I wouldn't stay with the circus forever, but I didn't know how long my tenure would ultimately last. As much as I was learning tricks to perform, I was always learning the business end of things from Taylor's decisions and the choices he made.

One day, after a routine show, I was in my room playing around with sleight-of-hand. I wasn't good enough to really do anything with it yet, but I liked practicing. Taylor knocked on my door and I glanced up enough to see it was him as he walked in. He would often call on me to evaluate a new act once he realized I had a good eye for talent.

"This is Mr. Clemens," said Taylor.

It was only then that I noticed a man had followed him in.

"Or Twain, or Mark, or whatever you feel like calling me," the other man said.

I immediately jumped up to meet him. "Clivette, sir," I said and shook Mark Twain's hand.

"You're impressive," Twain said. "Taylor says you do even more tricks than you were showing off today."

"Thank you." I shrugged.

"All dressed in black like that, you look like some kind of mysterious stranger," Twain said. He laughed.

I laughed, too, but I wasn't really sure what was so funny.

"That's a good stage name," said Taylor, and repeated, "the Mysterious Stranger."

"Or a good title for a book," Twain said.

We all laughed, but years later, after Twain was gone, I heard his publisher printed the book with just that title. I read it and have to admit to being a little flattered by his depiction. While hopefully I'm not Satan in the way the Mysterious Stranger is in the novel, but otherwise, I thought it was pretty fair.

"So, what's the trick?" Twain asked.

I hesitated.

"I know, I know, you're not supposed to reveal your tricks," said Twain.

"No, it's not that," I said. "It's just, there really isn't any trick."

"When you throw the knives, you're really just throwing knives?" he asked.

I nodded.

"You're just that good and certain that you're not going to hit your assistant?" Twain asked incredulously.

"And that they won't miss when someone throws them at me," I added.

"And when you're up on the wire, that's really just you? No secret support or trick of the light to hide an apparatus?"

"That's really just me."

"Remarkable," Twain said mostly to himself. "Almost like you've made some kind of deal with the devil." He laughed again.

It wasn't the first time I'd heard that remark.

We were on our way to Seattle. I didn't know it at the time, but the Seattle show would be my last. I would run into Mr. Twain again, under different circumstances, but I'll hold on that for now as I'm trying my best to tell this chronologically and not to jump around too much.

I was nervous about telling Taylor that I was leaving. I hadn't seen anyone leave voluntarily, so I didn't know what to expect. I'd seen people fired for drunkenness, or not showing up on time, or getting in fights, but I hadn't seen someone willingly leave. In retrospect, I realize I could have just left, just walk away at any time without a word. People joined the circus this way, just showed up one day and hopped the train, etc. So, it makes sense that you could do it in reverse and the show would go on without you.

Regardless, I felt an allegiance to Taylor that didn't allow me to do that. Maybe enough of my family had walked out on me that I wasn't willing to do it to someone else. I'm not sure what the reason was, but I felt like I had to announce my intentions.

Thinking about having that conversation made me anxious. The more anxious I felt, the more I put it off, which in turn made me feel more anxious. Finally, one day I blurted it out.

"I'm leaving after tonight."

We were in his train car, and he was in the middle of reading a ledger. I hadn't even knocked. Just noticed the door was ajar and pushed my way in. He placed his finger on a spot in the ledger, holding his place, and looked up at me.

"Oh?" he asked, his eyebrow raised.

"Thank you for all you've taught me, but I'm ready to do something else."

"Seattle?" he asked.

"Yes."

Taylor eyed me up and down, nodded, and then gave a curt wave.

"Thank you," I said. I started to walk out the door and turned back to look at him, but he was already busily scanning the ledger where he left off before I interrupted. I left the circus much like I joined it. Like the Wild West Show, I didn't have much to show for my time there. I had kept a few posters for a while, but they eventually became materials for me to draw on, and I sold the sketches and drawings I had done. At the time, I valued money more than nostalgia. Now I wish I had at least a couple tokens from that time. Even if my name never appeared on the bill, and it didn't—I was never that big of a draw, just a player in the machine—it would be something to look back and maybe it would have triggered even more memories. Regardless of the physical mementos I lacked, the skills and mindset I learned from Cody and Taylor were invaluable.

SEATTLE (1885-1886)

I might have remained with the circus the rest of my life. There were many people who did and made it their livelihood, but at a certain point, I wanted more control over my act and finances and my life in general. Being part of the circus meant I went wherever Taylor decided I went. I could haggle for more money, or to change my act, but he had the final say in everything. That was all on my mind for a while, but it wasn't ultimately the reason I left. Or at least not why I left where and when I did.

I left the circus because I fell in love for the first time. That's it; short and simple. I caught a glimpse of *her* before a show one night but didn't have an opportunity to approach her. I couldn't stop thinking about her, even while I performed that night. I was distracted by trying to find her in the crowd. It's embarrassing to admit. I had never spoken to her, or heard her voice, and yet I was completely taken with her. After the show, I raced around the tent to the main exit. People streamed by and dispersed into the night, but I didn't see her. I was convinced I had missed my opportunity and headed back inside to help clean up and prepare for the next night. Beyond all reason, when I walked back inside the tent, there she was, standing next to my friend George.

"Hey!" George said. "I thought you had gone and run away with, whatever the opposite of the circus is."

The woman laughed, and I fell even more in love. How could

24

I resist that beautiful lilting laugh and her striking smile.

"Funny," I said. "In fact, I was looking for her." I nodded at her. "Thank you for finding her for me."

I reached out my elbow, and she took it. There was no hesitation. It convinced me we both had the same immediate magnetic connection. I quit the circus that night.

Alice Flick was her name. The more time we spent together, the more we found in common. Neither of us dwelled on the past, nor really asked about it. We lived in the moment and bonded over things we loved and did rather than where we came from or who we were before we met.

She lived in Seattle, and so I moved in with her. Since I wasn't in the circus anymore, I needed to find a regular job to help the bills. None of the skills that served me on stage seemed to directly translate to work in the city. If we had lived in a more rural area, my strength and endurance might have served me well on the farm. But in the city? I read through the papers and walked the streets, looking for signs of businesses that were hiring.

One day, while Alice was moving some of my things to clean the apartment, she found a sketchbook of mine.

"What's this?" she asked.

"Oh, nothing," I said dismissively. "Just doodles."

"Better than doodles," she said, flipping through the pages. "Merton, these are wonderful."

"I'm glad you think so," I said and laughed. "I don't think they're going up in a gallery any time soon."

"No, but maybe you could work for the paper? They have sketch artists who do illustrations. It seems like you could do that pretty easily."

And, of course, she was right. I had seen the work of sketch artists before. They offered simple renderings to cut down on the cost of photography, not to mention the delays in developing the film. I could most definitely do that. I had worked at the newspapers years before in Wyoming and understand generally how it worked, so I put together a folder of my best drawings and went into the *Daily Press*.

The editor there liked my drawings but gave me an assignment as a test. He needed to know how quickly I could work, and if I could work under pressure. This was something that performing on stage had taught me, and it did translate from the show to working for the paper. The editor was very pleased with my work and offered me a job. The paper also needed someone to illustrate advertisements, and so I did this, too. Why not? Most of the time they just needed a simple drawing of the product. It was easy enough. Even then, drawing to accompany stories in the paper and the advertisements, I had a lot of downtime between assignments and was often bored. So, I went into the *Post-Intelligencer* and started doing the same kind of work for that paper. Effectively, I went from no jobs to four jobs.

Now that Alice and I had time and money to enjoy ourselves, we were very happy. Sometimes she came on assignments with me. We fell into a routine, and like the circus, I could have probably done this the rest of my life without regret.

One day, when I came home from dropping my drawings off, Alice greeted me at the door, holding a letter.

"What's this?" I asked.

"A letter," she said, laughing at me.

"Yes, yes," I said.

She handed it to me, and I turned it over in my hand.

"San Francisco?" I asked.

She nodded.

"*The Call?*" I asked. I opened the envelope and found a letter offering me a job at the paper. Apparently, the editor had seen my work and wanted me to be their sketch artist and ad-man. He said they'd match the salary I was currently earning from working at two papers.

"How did they know about both papers?" I asked.

"My brother lives there," Alice said. "He said it's the best paper in the area and he wants us to live closer to him."

"Ah," I said. "I have nothing against San Francisco. Frankly, it's a little warmer and drier than Seattle."

Alice was nodding, and I could see she was excited about the

possibility.

"Sure," I said. "Why not?"

Thus, we moved to San Francisco. As with all the big decisions we make in life, I can't help but wonder how differently my life would have played out if we had stayed in Seattle. But, I felt that way about the Buffalo Bill Show, and about the circus, too. Something always seemed to be pushing me forward and, frankly, I wanted to see what else life had in store for me. You get a lot further in life by saying "yes" to things, than you do by saying "no." Then, even if the experience doesn't work out, at least you have a good story to tell later. By this point of my life, I had already collected a number of great stories—crossing the Atlantic, meeting famous people, drawing for the papers, seeing all the 38 states, not to mention territories, countries, and so on. Now as I near the end of my life, I've come to the conclusion that the meaning of life is mostly about gaining experiences and sharing them with others.

SAN FRANCISCO (1886-1887)

The *San Francisco Call* was a big deal. There was some kind of magic with the editors and staff there and the news they printed; I always loved what they wrote. It wasn't the oldest paper in the States, it only started in 1856, but it had a charm that a lot of the other papers didn't. *The Call* had a simple motto, clearly stated—freedom, fearlessness, and fairness—and they stuck to it. There were a number of notable people who worked for it, too. For example, Mark Twain was on staff for a year or so from 1863 to 1864, and Frances Fane (Frances Fuller) and William Brown Meloney both worked there. Fane and Melony were people who wrote the truth, and they dug to find it. They didn't get the kind of fame that some of the muckrackers achieved at the time, but I always admired the work they did. Sadly, because *The Call's* unwavering commitment to truth often upset people, all the writers remained anonymous. You won't find my name attached to anything I wrote or any of the art I produced. Anonymity was the policy until about 1895 or so, and then only some stories had their authors named.

San Francisco was an incredible city to live in. As much as I had enjoyed Seattle, San Francisco was milder and yet there was always a breeze that kept it comfortable to wear slacks and a jacket. The gold rush was long over, but people still flocked to the city, and we had a lot of minor celebrities coming and going.

Holding down one steady job instead of two was nice, and Alice and I settled into a comfortable routine. I kept up with my exercises and training, even though I wasn't doing any of my acts professionally. Sometimes I'd put on a demonstration, or occasionally someone would convince me to get on stage, but it was nothing frequent or regular.

The job at *The Call* also got me a side job working with Bill Nye. He came into *The Call* one day, looking for an illustrator. He found his way to my desk, and we started talking.

"I'm Bill Nye," he said.

I'd never heard of him, so I nodded politely and waited for him to say more.

"I mean, that's the name I write under," he said. "My friends call me Ed. Or Edgar. Or Bill. Or really, whatever you feel like. I answer to about everything."

I laughed. "Merton," I said.

We shook hands.

"Here's the thing. I write books and tell jokes and all that. But I need someone to illustrate. I've had different people work with me before, but when I saw your work in the paper, I thought, that's the man I need."

"How did you know it was me?"

Bill laughed. "I asked around. The names might not be printed, but someone pays your salary."

"True," I said, laughing a little myself.

"Where are you from?" he asked.

My first instinct was to lie, but since leaving Seattle, I had started telling more of the truth with people. It was like having a secret identity. I reserved the "born at high seas" story for show business and kept the Wisconsin-born story for my private life. So I told the true version, even including the Wyoming pieces.

"No kidding! I was born in Maine but spent my childhood in Wisconsin—River Falls—and then moved to Wyoming, too! I must have just missed you because I guess I left there around 1881 or so. I've bounced around a bunch since. I'm only out here because of the lecture circuit. And, while I'm here, I just thought

I'd see if you're interested. You know, the publisher is always trying to stick me with this person or that, but I've got enough work under my belt that I think I can name a name and make that happen."

"I'd love to," I said. What else was there to say? I was always up for trying something new and Bill seemed like a good enough guy.

For the most part, we corresponded by mail. He mailed me a list of things he wanted drawings for, and I sent them back. Later, when I was back to performing professionally, when I passed through a town where he was currently living, he'd come see a show, and we'd meet and catch up. He died in 1896 in North Carolina, but I didn't hear about it right away and was too late to make the funeral.

This was also the time of my life when I first made dedicated time to painting in earnest. I had always drawn and doodled, and had dabbled in oils and acrylics, but now I really took time to paint. There was something about the sunsets and seascapes that made it impossible not to. It was hard to be surrounded by so much life and vibrancy and beauty and not want to try to capture it to enjoy later. Photography was growing in popularity, and I had seen some beautiful photographs people had taken, but that art was too static for me. There was no vibrancy or life or motion. Photography was great for documenting but not great for expression. For me, painting was a way of capturing the expression or moment or intensity of feeling on the canvas, as much as actually capturing the subject matter.

I might have stayed at *The Call*, completely happy and content with my work and painting the sea as a hobby, but that's never been how my life has rolled out. One day, Alice and I were at the saloon, just having a casual conversation when a man approached us and shot her in the head. You're never prepared for that. It doesn't matter how many times you read stories about violence or crime. We had mock shootings in the Wild West Show and sometimes added drama to the circus by using blanks and feigning a shooting. In those, the victim of the shooting reacted

dramatically to broadcast the obvious injury and pain to the audience.

Sometimes, we used live ammunition during a show, and someone would actually be shot. I had even seen people shot by accident in the shows, but no gunshot injury had been very serious. The few times it happened, the person flinched and reacted, but they did their best to keep the show moving.

But this time, I knew it was different. Alice didn't react at all. She just fell backwards in her chair and didn't move again.

One minute we were talking and laughing and the next she was dead. After the echo from the shot stopped, there was a moment of utter silence. Everyone was still and almost frozen. I leapt for the man, but he shot himself before I could stop him. Then, I turned to Alice, but knew it was too late. She had been so full of life, but now a mere glance at her revealed the truth that she was gone.

The police questioned me, but I had little to offer.

They asked, "Did you know Samuel?"

"Who's Samuel?"

"The man who shot Alice."

"I know several Samuels, but not that man," I said. I was told later that I was in shock, a term I had never heard of before. Apparently, "shock" was a new thing. Some thought it was a sort of "vasomotor paralysis" caused by "splanchnic blood pooling"—whatever that was. Another theory was shock was caused by a failure of "vasodilator nerves" and a "generalized arteriolar vasoconstriction." In plain English, as I asked the doctors for back then, they said, "decreased blood flow causing a shutting down of nonessential systems." I found this all very interesting as my reaction to the loss of Alice was to focus on things like this, learning more about the medical aspects of my initial response. I needed to make sense of why I didn't break down into tears or openly weep when the police were questioning me.

As for the killer, the police proposed several theories. Maybe the man was a spurned lover? Maybe the man confused Alice for

someone else? Eventually, they uncovered that Alice and Samuel had been divorced five years ago, in Oklahoma. She had moved to Seattle to start a new life, under a new name. I never knew. From the information they gathered, Samuel was known to be violent, and the judge granted Alice the divorce and assisted in her name change documents.

With Alice gone, there was nothing to keep me in San Francisco. The work at the paper became automatic and uninteresting, and I started looking for new opportunities. Something new to challenge me. And, though I didn't think about it at the time, something to distract me from Alice's death and absence.

WHAT'S VAUDEVILLE?

I know they keep saying that radio or film or movies or whatever they're calling it these days is killing vaudeville, but maybe you don't even know what vaudeville is, or was. Let me explain because vaudeville was unlike any other entertainment experience.

Before vaudeville, you had the following as choices for entertainment: theatre (musical, plays, etc), the circus, museums, freak shows, burlesques, baseball, and musical and dance acts. I'm sure I'm missing a couple in there, but these were things you attended from start to finish. You made plans. You went out to a meal maybe, and then you saw a show. Sometimes one of these shows would run twice a day, maybe a matinee and then one in the evening. Most of these shows ran two-to-three hours, occasionally four. It meant a lot of sitting and a big commitment of time for the audience. If you were late, you missed a vital piece of the show and people around you were reluctant to catch you up because it would distract from the performance and then they'd miss things. If you left early, you didn't know how it ended. In short, it just meant if you went, you got there on time and you stayed until the very end. If the show ran two hours, it generally meant at least a commitment of three hours.

The revolution of vaudeville was that it changed the timeline. Start time and end time was no longer a fixed point in the

evening. It was a show, made up of shows, and it kept playing them over and over again on repeat. And, there was a variety of shows within one vaudeville show. If you didn't like magic, you could skip that one and catch the comedian or acrobat or shadowgraphist instead. Tickets were inexpensive enough that you could pick and choose and come and go as you wanted.

Where did the first vaudeville show take place?

France. Or so the French say. The idea was a variety of entertainments that didn't have a "moral intention" or lesson the audience was supposed to discern from a performance. The French variety show was intended to be light and frivolous. When the idea spread to the United States, it incorporated "entertainments" here that were uniquely American—like the minstrel shows or saloon-kind of show—and adapted other aspects in an American way.

So what was a typical vaudeville show like?

They were all a little different, but, in general, they consisted of eight or nine carefully curated acts that served specific purposes.

The first act was "the opener." I know, it's not a very original name, but it's better than what vaudeville veterans called it. We used to refer to it as the "dumb act." The idea of the opener is to give the audience something to watch if they showed up on time, but nothing that anyone would particularly miss if they were late. It had to be "dumb," in that it didn't require any thought or carryover from one minute to the next. The best dumb acts were animal trainers, or new acrobats, or jugglers. Sometimes a comedian would be an okay opener. Typically, the only people in the stands for the openers were family or friends of the opener entertainers or people who wanted to secure a good seat for the second act.

The second act didn't have a clever name, but it was often better and more entertaining than the first. Its function was to get the audience to stop getting snacks and drinks and to actually take their seats. It similarly had to be kind of "dumb," because the audience was often shuffling around and getting settled, but

a lot of new talent got their start as a second act. Frequently this was a sibling duo—singing or dancing or juggling—or maybe a male-male song and dance team, or maybe just an up-and-coming musician. The benefit of a musician filling this spot was that songs were relatively short. Audience members could enjoy one song if they had missed the previous one.

The "flash act," or third act, was the first real act anyone cared about. It was the first large production act and was often assembled behind the second act as they sang or danced. People frequently skipped the opener entirely and showed up mid-second act but came to stay for the third act. A magician often filled this spot. The job of the flash act was to get the audience to pay attention, snap them out of the side conversations they were having during the first or second act, and to demand their attention on stage.

If you were a latecomer, the fourth act was often your draw. It was also a good time to show up if you really wanted to see the fifth act, because it meant you had time to get settled without missing any of the fifth act. If you were already in the stands, this one was designed to keep you there. This was a singer, or comedian, or comedy team. Maybe a dance act. It was meant to be engaging and was well-rehearsed and polished but didn't require a big set. This was so the first headliner could set up behind them.

The first headliner took the fifth spot. When you looked at the posters for vaudeville, you'd see each of the headliners mentioned. A lot of care went into choosing the headliners for each vaudeville show because everything needed to flow and capture the imagination of the audience. If the fourth act was comedy, then the fifth act would be dance or music. If the fourth act had been a singer, then five would be a comedy act, designed to keep you laughing and in your seat.

Six was the trickiest spot. It had to give the audience a breather from the fifth act and prepare to transition them into the seventh. This is where the best dumb acts were slotted. It was people who really had their schtick down and knew how to work an audience,

while also letting them move. The acts in the sixth spot were better than they appeared, but were, by design, not attempting to outshine the acts that would follow them. Comedy jugglers worked well. Ballet dancers were a good option. Occasionally musicians.

The seventh act was another big one. This was a full stage performance, designed to build the excitement for the eight spot.

The eight spot was the headliner everyone came to see. It was the one act that all the rest of the show was curated around. If it was a magician, then there were lesser magicians at the earlier spots, building up to this one. If it was a musician, then this musician had a set bigger and grander than any of the other musicians who had performed previously. You get it, right?

So, then what was the purpose of the nine spot as the final act of the show? The ninth and last was the "haircut act" or "chase" or "chaser." This was an act so bad, people literally ran out of the show. The chaser took the dumb act to a new level, and the crowd knew nothing good was going to follow. So they left. I remember seeing someone sculpting from clay once, and the finished products looked nothing like the people they claimed they were sculpting. They were known people, like presidents, so everyone realized just how bad this act was. Sometimes the ninth act was an animal show, where the animals didn't listen and the trainers struggled for control. That act could kill in the right hands, but as a chaser, it wasn't played for comedy. Towards the end, they even used films as a way to chase people away.

To put it plainly the purpose of the ninth show was to empty the seats so the entertainers could start setting up the next show. They wanted to sell more tickets. If audience members wanted to come back and see the show again, they had to pay again, not just hang out in the stands. And repeat was just what they did. The idea of a continuous show like this could only work in vaudeville, because of the variety, because of the interruptions and pauses and opportunities to get up and leave, and because there were so many acts to choose from.

Of these acts, I've played all of them. My first step on the stage

of vaudeville was in the third slot. I quickly moved to the headliner slots, and because I was good at working a crowd, I frequently was slotted in the difficult six spot. Because I had so many different tricks and abilities, I frequently filled in as needed. When someone didn't show, I'd put on a costume and play a dumb act to start the show. I even got to be a chase once, which was far more fun than I had thought it would be. It was a good opportunity to try out new material that I wouldn't have dared otherwise for fear of it falling flat. When your job is to chase people out, who cares if it falls flat or not? Being a chaser really was a unique opportunity.

The variety show, as I've described here, was a great leap forward in entertainment. But it also allowed a lot of people who wouldn't have been employed a place to work. Vaudeville didn't care what your religion was, or sex, or race, as long as you had an act to perform and could entertain, you were in. Unlike the circus, or Buffalo Bill's show, it didn't require a lot of set-up. It was a well-oiled machine that eventually evolved into the vaudeville circuits.

Enter, the Orpheum and the Keith circuits.

WHAT'S THE ORPHEUM CIRCUIT?

The Orpheum began in San Francisco in 1886, which was where I was living at the time. I was experimenting with different acts, building up my repertoire of tricks and bits and pieces that I could turn into a performance. I wasn't sure exactly where I'd perform them, but when I heard about the Orpheum opening, it seemed like the perfect place for it.

At first, the Orpheum was just another theater.

Technically, Gustav Walter founded the Orpheum, but it never would have become what it was without Martin Beck. Beck had an eye for talent and his mind had the ability to juggle the lineup until it was the precise balance of dumb and spectacle, and the right mix or variety to keep the audience engaged. Beck was the booker, the manager, the organizer, and Gustav was the money, the investor, the perfect partner to Beck. Once the San Francisco Orpheum started to take off, Gustav opened another in Los Angeles and then Sacramento. Now they could rotate the talent between the two theatres to give audiences in each city something new they hadn't seen before.

Gustav didn't have all the money in the world, but he was able to partner with existing theatre owners and together they rebranded other theatres around the United States as Orpheums. In ten years, there were Orpheums in San Francisco, Los Angeles, Sacramento, Omaha, Kansas City, Denver, St. Joseph,

New Orleans, and Chicago. In twenty years, they had added locations in Oakland, Memphis, Minneapolis, St. Paul, Winnipeg, Duluth, Des Moines, Salt Lake City, Lincoln, Sioux City, Vancouver, Portland, Calgary, Stockton, and Fresno. But, I'm getting a little ahead of myself.

My time with the circuit was from 1886 until about 1905. I saw it grow from one location to several. Even when there weren't locations that bore the Orpheum name, the "Orpheum Circuit" became such a big name that we'd play the Chicago Opera House, or the Majestic, or any other theater that would have us. I guess what I mean to say is, it wasn't long before the brand of the Orpheum spread in popularity, and it became more about the show than where it was housed or performed. Most the theaters we'd play in had between 2,500 and 4,000 seats, and we'd sell them out regularly.

In the east, there was a rival circuit called the Keith Circuit. And then it merged with the Albee Circuit. And eventually everyone merged together into one big rotating show. But before that happened, in the early days, Beck and Gustav somehow worked out an arrangement with the Keith Circuit. The deal amounted to, "We get the West, and you get the East." By "West," we meant Chicago and anything west of there—which, frankly, wasn't really true, because we played Indianapolis a number of times—but in practice, the Keith Circuit got the big theater markets of New York and the East Coast cities.

New York was a big market to lose out on and tackling the "West" required some creative logistical thinking. From Chicago to Los Angeles, and everything north and south of there, was a lot of ground to cover. It took days to travel between cities, which meant there was time when performers weren't being paid. On the Keith Circuit, performers didn't get paid if they weren't on the stage, but they were often only not performing for one day, at most two, because the cities out east were so much closer to together. They covered less territory. Beck knew he couldn't get away with that. He needed to offer something different to attract good performers and to keep them, so he offered a weekly wage.

Instead of an on-performance-based pay, everyone got paid weekly. People called it "travel pay," and it was a big attraction to get people to join the Orpheum Circuit. Being paid for our idle time was an innovation.

When I hear people talk about the Orpheum, they describe it as a traveling circus, but that really isn't fair. The circus was one thing that went from stop to stop. With the Orpheum, Beck had to juggle a whole barrage of acts moving from one stop to another. Each city on the circuit was always being served simultaneously. The acts currently in Chicago might move to Milwaukee, but Chicago needed a new set of performers to replace the ones who were leaving, and the acts in Milwaukee needed to be enroute to St. Paul, and St. Paul was moving to Minneapolis, and Minneapolis to Sioux Falls, and so on, ensuring that each city had a new set of performers on a weekly—or biweekly—basis. It was like one big snake, eating its own tail perpetually.

As a performer, being part of the Orpheum felt no different from Cody or Taylor's shows, but as a manager, it was a constant battle to spin all the plates while juggling, patting your head and rubbing your belly. If a train broke down between two stops, that was a problem for everyone on the circuit. Thankfully, that didn't happen often. And even more thankfully, it wasn't my problem to sort out.

MY ORPHEUM ACTS

I needed new, more spectacular acts to capture the interest of the audience (and to ward off my own boredom), and as I developed new acts, I also moved up the billing to the headliner acts.

As my acts and fame evolved, so did my names. At first, I was Clivette the Great. Then The Great Clivette. Clivette: The Man in Black. The Man in Black. Then finally, just Clivette. When you achieve the level of fame where you can go by a single name, you know you're in good company. Cody. Barnum. Houdini. Mozart. Socrates. You get the point.

I started simple, doing the things I already knew how to do. The slack-wire act. Juggling. Throwing knives. Tricks on horseback. Acrobatics. Contortion. After a while, I started to combine those into entirely new sets. It wasn't long before the juggling and acrobatics and contortion turned into my famous "32 divisions of the mind" act.

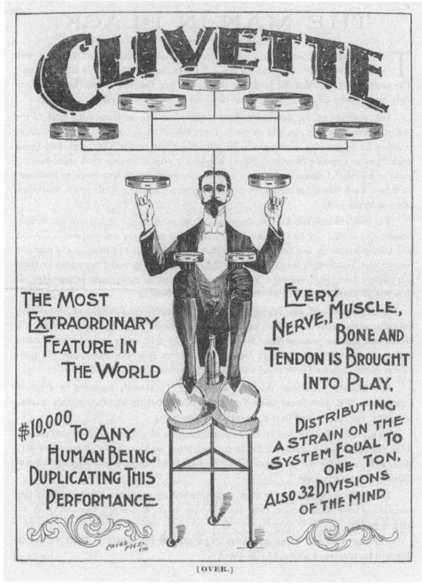

[OVER.]

The poster shows an image of me balancing and spinning objects on my fingers and nose while standing on objects standing on end precariously balanced on top of a table with the words: "*The most extraordinary feature in the world! $10,000 to any human being duplicating this performance! Every nerve, muscle, bone and tendon are brought into play! Distributing a strain on the system equal to*

one ton, also 32 divisions of the mind!"

It sounds impossible and exaggerated, but it was all true. What's remarkable is that the image doesn't truly do the feat justice. Because the image is flat, you can't tell that I was performing on a floating pedestal, balanced on a bottle. I was spinning tambourines with each foot in opposite directions, with spinning tambourines on my knees. I had a rack in my mouth, with five more tambourines spinning. Everyone assumed the objects were light-weight, but I've yet to find a person who can hold the rack upright, let alone with his mouth like I did.

Physicians and doctors came to evaluate and challenge me. They didn't believe it was humanely possible, and they intended to prove me a fraud. The most famous was Professor D. L. Dowd from the Institute of Physical Culture out of New York. Professor Dowd enlisted fifty of America's leading scientists and wrote their evaluation of me in *The Scientific Review*. I don't have the actual review here in front of me, but it says something like, "Clivette has reached the culmination of physical and mental control. His act calls for 32 divisions of the human man, and the strain is equal to a ton distributed over his body."

Everyone assumed there was a trick, but like I've said so many times, there was no trick, and the hope of prize money was a solid hook to bring in the crowds. Occasionally, an audience member would brazenly accept the challenge to duplicate the trick, expecting to take home the prize money, but most of them failed before even spinning a single plate. As I grew more confident, the prize offered grew from $1,000 to $10,000, but no one was able to claim that prize.

Sometimes before a show, I would wander through the crowd, partly to calm any pre-performance nerves and partly because I liked to hear the chatter and anticipation of the audience. I loved when I'd catch two friends making bold statements about how they could, "easily pull of my act with all the same apparatuses and unseen wires!" I rarely made it known that I was there, but when I had an opportunity to pull someone from the crowd, I always made sure to grab one of those folks to challenge their

hubris. It was always fun to watch their smugness disappear. Not only it was personally satisfying, but it also meant they'd go back and tell their friends and their friends would share that story with others, and that meant more tickets.

As with all live performances, seeing it in person is so different from seeing a poster or drawing, or even a photograph of it. What looked possible on paper, became wholly impossible when seen live.

How did I do it? As I've already established, there was no trick. It just meant a lot of practice. It meant staying in shape and exercising my mind and body. I required the strength and endurance to be able to stand on the side of a plate, and I also needed the fortitude of mind to block out distractions to ensure the focus necessary to perform the act. With repeated practice, the mind and body knew what to do as a sort of muscle memory without the thought, and that's the level that I rehearsed to achieve. When someone challenged me from the crowd (and they often did), or the next act was setting up behind me, I was able to continue without fault.

The newspapers said kind things about me, and I have a nice collection of the articles. Back then, there was a service you could pay for that would search for mentions of your name and mail you the clippings from the papers. Imagine being paid to read the newspaper!

But here are some of the reviews from my early days:

"Clivette, champion slack wire walker of the world, gave an exhibition this afternoon on the wire and in juggery near the St. Charles Hotel. It was first class and will be repeated at the same place at 6:30 o'clock to-night." That one was pretty similar to: *"On Sunday, May 16th, the great slack-wire walker, Clivette, will appear at Goodwater grove. The Oakland papers mention the feats performed by Clivette at Badger's Park as something wonderful. His tricks are unlike those of other slack wire walkers. He does everything while the wire is swinging to and fro."* These are both from just before I joined the Orpheum when I was still sorting out my act and figuring out what I could offer. I liked that they called me *"first class"* and *"champion slack wire walker,"* as if there were slack

wire competitions. I mean, in a way there were, but no actual medals were awarded.

"*Yesterday evening a large crowd gathered at the corner of Marsh and Nipomo streets, to witness the slack wire walking of Mr. Clivette, and to hear the comic songs of his partner Mr. Gilbert. The performance was a very clever one and well worth attending.*" At this time, I wasn't formally with the Orpheum, though it was right before I started on the Circuit. It was just me and an acquaintance putting on a show. If you didn't know, *Marsh and Nipomo* is in San Luis Obispo, CA. And, while I wish I could say the Mr. Gilbert in question was fifty percent of Gilbert and Sullivan, it wasn't. Sadder still, I don't remember who this particular Mr. Gilbert was. I often partnered with people, some that I had known for a while and others that I just met.

"*Clivette will perform a number of daring feats!*" Okay, so that isn't so much of a review as it is a proclamation. It still made me happy to read it in the newspaper.

"*A series of juggling tricks that introduced several beautiful novelties, and ended by an exhibition of shadowgraph art, which may literally be said to put all past efforts of that sort in the shadow. Dandy Clivette is the sobriquet applied to the individual who carries this honor.*" Dandy Clivette. I guess that's a compliment, right? Who doesn't want to be well-dressed and admired?

"*Clivette, the supple and agile little French equilibrist, does one of the most artistic and entertaining acts of jugglery that has ever been presented to the American public.*" The *most* artistic and entertaining acts, hyperbole? Maybe, but I'll accept it.

"*Clivette in his feats of equilibrium, has apparently conquered the law of gravitation. Bottles, balls, pans, etc, floated around in the air at his will. His quadruple tambourine act was well received. His shadowgraphs were immense.*" I liked the "*conquered the law of gravitation*" part and used that on posters for a time.

Not only did these kinds of reviews send customers our way and boost my ego, they also served as great promotional materials for posters and handbills and broadsides.

I have plenty more, but after a while, they begin to repeat

themselves. Afterall, there are only so many ways to say, "*The Great Clivette does it again.*"

As one would expect, the act did eventually take its toll on me and people on the circuit had seen that act, so it was time for a new one.

This is how I came to become a necromancer and master shadowgraphist.

NEW TRICKS

As a performer, I look at performance differently than an audience member. Instead of being lost in the enjoyment of the act, I always dissect what the performers are doing and how. While so many "tricks" are a result of practice, physical endurance, and training, some are clever manipulations that remain invisible to the untrained eye.

The most obvious tricks are the ones perpetrated by the people who call themselves occultists. Some of the mind-readers or mediums or clairvoyants, or whatever they are calling themselves now, only rely on their ability to read a person's body language and to pick up on subtle cues. In my day, the best would take a volunteer from the audience, someone they had never met before, and "channel the mystical arts" with them. In truth, the performer was conducting an interview. The skilled performers made it feel natural, and it didn't feel like an interview to the participant, or to the audience, but that's what in fact was happening. Even if a participant steeled him or herself against it, convinced they weren't giving away any information about themselves, the performer nudged it from them anyway. The trick was to be likeable and observant.

It's not so different from a salesman stepping into someone's home and selling him or her something they don't already want. The homeowner doesn't know they are about to be manipulated

because they think they are in control, but even that works in favor of the salesman. He offhandedly compliments the homeowner on a unique object, or remarks on a piece of sports memorabilia, or identifies a heritage from a photograph, and then uses this verbal leverage to connect with the homeowner. Of course, it's vital the salesman appear to do this organically as part of a separate conversation and then appear surprised that he and the homeowner share this thing in common. It's the key in the door to information.

The same principles are equally effective on the stage. A woman dressed in black might be mourning, but making that observation is dangerous because it's perhaps too obvious. The audience would see right through you. Instead, you might notice a locket. The locket has a hinge and a clasp, so you know there's something inside. Maybe it's a lock of hair from a deceased child or spouse or parent. Or maybe it is a small portrait of someone close to that person's heart. A pocket watch can be a sign of wealth, so it can be safe to make an assumption about what business or the line of work the person is in. Dirt under fingernails can indicate a person who does manual labor. Most people who go to a show have taken the time to make themselves presentable, but residual dirt sometimes remains and indicates it's a lifestyle.

Every time the performer gets something right, they gain further trust from the participant. If the performer guesses poorly, they still have an opportunity to win the participant back, but they have to be thoughtful about how to recover. Sometimes the recovery can be even more effective than being right in the first place.

It also helps that people typically only dwell on deceased loved ones, their own death, their future, and opportunities at love. It's easy to have a set of canned responses to deal with each of those. The answer is vague enough that the performer can adjust on the fly, if necessary, but on target enough to gain the participant's confidence.

But those are all "tricks," or maybe "skills" is a better word,

for the good clairvoyants.

The bad ones, the true hucksters, use levers and pedals and the like to manipulate the table, or objects on the table, to convince the participant that spirits are indeed in the room. The problem with this kind of performer is they raise the expectations of the crowd to an unreasonable level. The good medium, that I described earlier, is able to use the information gleaned from a participant and reflect it back to them in a way that causes introspection or a realization they were incapable of seeing on their own. Unfortunately, while effective one-on-one, it doesn't play nearly as successfully in front of a big crowd. Levitating tables do. So do crystal balls that float around the room and loud noises, supposedly generated by the spirits.

I have always held the opinion that using levers and pedals and tricks cheapens the act, so when I tried my hand at occultism, I avoided the mechanical manipulations. I did add in elements of sleight-of-hand and illusion from what would eventually become my magic act. However, my days of an "occultist" were short. Every now and then, when I grew tired of my other acts or we did multiple nights in the same town, I'd revitalize it. Sometimes I'd even use a different name and perform as an occultist earlier in the show, and as a shadowgraphist or magician, or whatever else the show called for, later as a headliner. It kept me fresh and interested and was a way I could help when someone else was injured or sick.

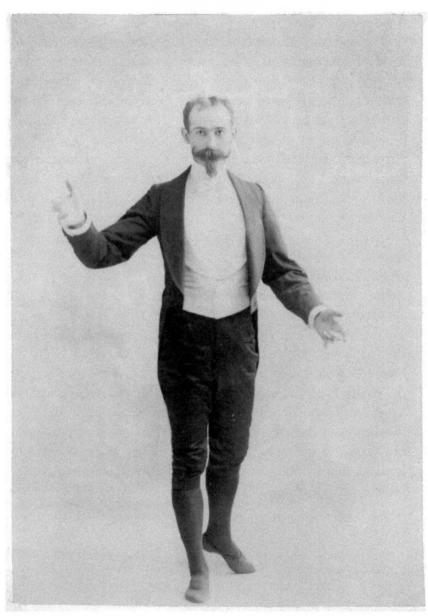

Shadowgraphy is one of those arts that came and went during my time on the Orpheum Circuit, so I'm not shocked how few people know what it is today. Occasionally, I'll mention it or run into someone who asks about one of my shadowgraphy sets, and I get odd looks from bystanders. Shadowgraphy? What's that?

You might have heard of something called "shadow puppets," but that really underrepresents the skill required to manipulate the fingers and hands into the right position to create art. And that's to say nothing of using the light to depict motion and depth. A "shadow puppet" is when a father puts up two fingers against a light and plays "Little Bunny Foo Foo" with his child. True shadowgraphy is an art and a skill.

Shadowgraphy comes from China. It's an Eastern art that spread its way into the West. I went to China and learned directly from the Chinese practitioners. All the exercises that served me well for spinning plates and feats of balance turned out to be essential for shadowgraphy as well. Shadowgraphy requires you to be able to see beyond what is in front of you, and to think abstractly and creatively about how to manipulate the familiar into something recognizably different to others. Using mostly just your hands and light, how can you trick the eye of the audience to be convinced they are seeing something other than what they are?

That's the trick and it's the bridge from shadowgraphy to magic.

It should be obvious, but it's vital to state: light makes the trick. Good lighting is essential for broadcasting the image where you want it. On stage, lighting is even more important. Here is the setup I found most effective. One of the best lights is an ordinary tallow candle placed inside a large cigar box. Cut a hole about two inches square in the side of the box facing the sheet or canvas. The sheet should be about six feet from the light. The room needs to be entirely dark, except for the ray of light from the candle. If necessary, you can use an oil lamp or even electric light, but candlelight truly is best. The flame gives off a warmth that the other sources of light can't touch, and the movement of the flame helps with the animation of the images you're producing. Mirrors can be added to the basic setup for effect and duplication, but it requires an additional level of attention and consideration because extras can backfire just as often as be effective.

When someone asks how to perform a trick, I tell them about the setup I just described, and then I recommend they play. "Play?" they always ask. Yes, play. Just like a child. Experiment. Dabble. Try some things for yourself, and you'll likely surprise yourself with what you can create. Many of my shadowgraphs came from just that kind of play.

People new to shadowgraphy always ask for examples, and I'm always happy to demonstrate some of my favorites. One day, I might get around to writing a book about the art. But for now, I mostly direct them to the interview I gave on January 6, 1903, with the *New Orleans Item*. I gave an overview of the art and walked through some basic shapes: rabbit (not just the basic two-fingers for ears variety!), devil, swan, duck, and a flying bird. The sketch artist, a job I once had but I think I've already talked about that, worked with me to capture illustrations of my fingers and the shadows they'd create.

For example, and posterity, here's an example of the swan. I like to demonstrate this one because it makes use of the arm and encourages the artist to think beyond his or her fingers. For the swan, place your thumbs and first fingers together, with the middle fingers straight, the third and little fingers bent under to form the lower portion of the throat. See below:

Once you've mastered a shadow, it feels simple and obvious, and you can't imagine how someone is unable to do it as well. All

I'll say to that is that it's one thing to make the shadow and an entirely different thing being able to bring the shadow to life. In the case of the swan, you can rub the ends of your little and third fingers against your palm, and this will give the illusion that the swan is swallowing. You can also move your forearm to make the swan swallow, or rock gently back and forth as if it's moving across a pond. This is where observation comes in handy. You must observe the creatures you're going to create on the screen so you know how they move. Next, you play and experiment until you come up with something that works. Then you practice and rehearse it so you can do it without hesitation. Create a litany of shadowgraphs you can reliably create and find a way that they make sense together. How does a devil, a swan, a rabbit, and a flying bird all come together? Finally, you build your act by incorporating the images and movements into a story. Now you have a show.

That, in a nutshell is shadowgraphy.

As a performer it wasn't nearly as rewarding or thrilling as some of the other acts I was part of. It was sometimes an opportunity to showcase talents I didn't have an opportunity to do otherwise—like singing. By no means did I have a beautiful singing voice, but I enjoyed song. While few would pay to see me sing as a headliner, they did enjoy a shadowgraph set where my shadows sang. Often to comic relief, but singing nonetheless. It was easy enough to make a shadow of a man's head appear, and then to mimic singing with my fingers and hands. Sometimes I'd take the popular songs of the day and act them out, transforming the various lyrics into illustrations on my sheet. Other times I'd just have a shadow-bust of a person singing, generally in a comedic voice for effect. The audience responded well to that. After I gave them something popular, I'd follow it with a song from the past. Often it was something my mother used to sing to us. There was something about the nostalgia of the older song that always seemed to bring even bigger whoops and cheers than the more recent songs. So, I learned to close with the classics.

In the end, shadowgraphy was more a curiosity than anything

and didn't capture my interest for long. Though I admit that, later, once my daughter was born, the tricks and storytelling came in handy again.

But, as I said, shadowgraphy was a passing fancy for me. The thing I was probably most famous for on the Orpheum Circuit was magic. This, really, was an opportunity for me use all the skills I had learned previously.

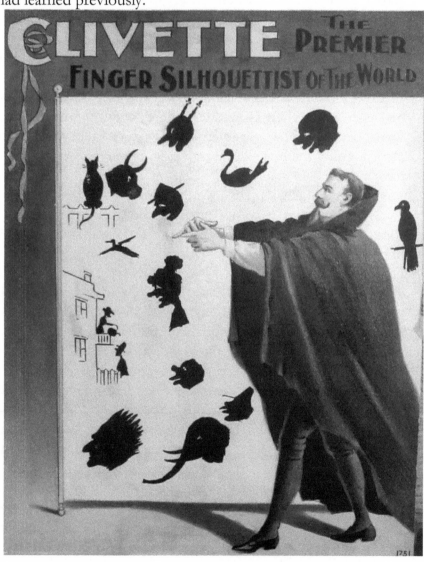

CATHERINE

The other thing the Orpheum gave me, beyond a career and a method of seeing the world, was the opportunity to meet my future wife. I had been in a few relationships after Alice's murder, but nothing ever serious, and nothing ever lasting. Usually I'd meet someone in a town we stopped in or connect with a fellow performer. I don't know if the relationships were doomed because of how I lost Alice or if I just wasn't ready, or mature enough to balance someone else's aspirations with my own. When I met Catherine though, everything clicked into place. Someone more romantic might say the stars aligned. Was it true love? I tend to believe there are many different compatible people for everyone, and true love is more a matter of timing. Finding that right person, at the right time, in the right place. It does no good if the right person for you is over in India and you're in London. For me, Catherine was that right person, right place, right time, and we grew together and made one another better people.

We met in 1893. We were married the following year and were never apart for more than a couple of days all together. She was an incredibly gifted opera singer who trained at the National Conservatory for Music in New York and Paris. Singing was only a fraction of what she was really capable of. She was an incredibly selfless performer, who gave the show exactly what it needed and

no more. She could have blown the socks off any audience every time, but the show rarely called for that, so she rarely did. It was more than a little embarrassing that the playbills listed her as an "also performing" or they would say something like, "The Great Clivette! Assisted by Madame Clivette" (and her name often was in a significantly smaller font).

HIS EQUAL HAS NEVER LIVED IN VERSATILITY, ORIGINALITY AND ARTISTIC FINISH.

THE GREAT

CLIVETTE,

ASSISTED BY

MME. CLIVETTE,

IN SPECTACULAR PRODUCTIONS OF MAGIC, MANIPULATING, FINGER SILHOUETTE, ILLUSIONS, THAUMATURGICAL EXPERIMENTS, Etc.

She said it never bothered her.

She had an entire career and life before we met, and I loved her all the more for it. Before she was billed as the "veiled prophetess," assisting me on stage with my mesmerism, magic, and mind-reading acts, she performed light opera—sometimes called operetta. Though it is an art and craft of its own, it is often looked down on by true opera purists, I suppose because operetta began as an offshoot of opera but with shorter more direct messages and a smaller orchestra. Unlike traditional opera, operetta requires performers to be able to sing, dance, and perform dialogue. Seeing an operetta is more akin to a musical play—if that helps at all. And, lest you still think poorly of it, know that many great composers created music just for the operetta. Perhaps the best known among them are: Johann Strauss II, Franz von Suppe, Jacques Offenbach, Franz Lehar, and W. S. Gilbert (half of the act that would become Gilbert and Sullivan).

One other thing you should know about light opera is that it is often funny or satirical. This is important because generally when people hear someone is an opera singer, they assume that person is proper and stodgy and dry. Nothing could be further

from the truth with my Catherine. Her humor and wit were among the things I loved most about her, and they served her well on the stage. She saved me more than once during a performance that was going sideways, or when I had dropped a prop, or needed to stall for time. Catherine instinctively knew when she was needed and just how to break the crowd into laughter. By the time they had settled down again, I would have recovered, feign irritation at the interruption, and go on with the show.

By 1918, Catherine had retired from performing entirely and had dedicated herself to social concerns and teaching piano and voice from our Greenwich Village house. The lessons were more for fun than anything and to help young people gather the confidence and training they needed to pursue their dreams. Animals were another love of hers, and together we fought to end animal cruelty. Catherine's true calling, in the third act of her life, was civic activism. She was the first vice president of the World Anti-Narcotic Union, and she formed the Society for the Prevention of Unjust Convictions. She was active in the Justice Forum and lectured and spoke on educational and civic subjects wherever needed.

To give you a sense of what I'm talking about, you should read up on the Seabury Investigation. Seabury, everyone called him Judge Seabury even though I think he was a lawyer not a judge, led the investigation into the corruption that eventually involved interviewing 1,000 witnesses and 300 of those giving testimony during trial. But he never would have gotten to that point if Catherine hadn't gathered 35,000 names to force Roosevelt's hand to launch the investigation in the first place. She did that through sheer determination of will and a strong sense of righteousness. Eventually, the case revealed corruption and connections between the government and organized crime. Catherine's initial interest in the case came about because of a young woman named Vivian Gordon who was arrested unlawfully and then murdered before she could testify. At the time, Catherine was fighting for justice for Vivian but the case

grew into something much larger.

All that comes much later. I'm sorry; I realize I'm jumping around a lot, but frankly, it's hard to write an autobiography in one neat seamless timeline. Life doesn't work that way. And you need to know about Catherine before you understand my magic act.

MAGIC!

Joining the Orpheum Circuit was a nice way to travel in a controlled way. It wasn't as frantic as the Circus or Cody's show. We often stayed a week or even two in a city. We had time to explore and get to know some of the people in the different towns, find a favorite place to eat, read the local newspaper, maybe even find a library if we were lucky. I had always been a reader, but my tastes had matured by the time I was on the Orpheum tour. Instead of reading for entertainment, which I still did now and then, I primarily read for self-improvement.

This meant a lot of non-fiction. I was inspired by how Cody and Taylor wrote their own stories and revealed some of the tricks of the trade, and I read all their books. It was kind of funny to have worked with them both and then to read what they actually put down in print. Sometimes they were more vulnerable on the page than I had ever known them to be, and other times I knew they were outright lying in print. I learned valuable lessons from them, most about marketing and how to work with people—both professionals and the audience.

But the books I couldn't get enough of were the ones by magicians.

There was something about magic that captured my imagination, and I found the physical challenges rewarding. I was eager to learn as much about the discipline as I could, so I turned

to books.

Which books you ask?

Honestly, I read whatever I could get my hands on. Some of the cities we passed through had great bookshops, and I always made a point of stopping in and seeing what they had. Occasionally, very rarely, I could find a magic store that carried manuals, books, and props. Even more rarely, one of the people I'd be performing with would have a book and we'd swap. Oddly enough, I found myself to be one of the few people who read. I'm not sure what else everyone did with their down time, but a book seemed like the natural choice. They were portable, engaging, and often entertaining. But, to each their own.

My favorites: Reginal Scot's *The Discoverie of Witchcraft*. The point of this book is to debunk witchcraft, and to show how "feats of magic were done." I love how old it is. Since it was published in 1584, it was nearly three hundred years old by the time I first read it. I remember opening the pages and just smelling history. It was spectacular. There are some illustrations, but mostly it is a careful walkthrough of illusions and sleight-of-hand and general trickery.

Hands down the best book, and the one I return to again and again, is Angelo Lewis' *Modern Magic*. He wrote it under a *nom-de-plume* because he was afraid of being found out. He went by Professor Hoffman. I suspect the "professor" part was also intended to add some credibility to his book. When I was becoming known as a magician, this was the book that everyone referred me to. The book was the entry point for William Robinson, better known as Chung Ling Soo. Alexander "the Man who Knows"? His, too. The Howard Thurston, master of card tricks? Yep, even Thurston said this book was his "gateway into the mystical arts."

There are two more books worth mentioning. Thomas Frost's *The Lives of the Conjurors* is, I think, the very first book about the history of magic and magicians. In many ways, it legitimized the art. Frost's book is like a "who's who" of magic, and he makes so many references to different books that it also works as a path

toward learning more. The other book many magicians I knew had read was Jean-Eugene Robert-Houdin's *Secrets or Confessions of a Magician*. Later it was printed as *Memoirs of Robert-Houdin*. I know, because I bought it and was disappointed to realize I had already read the book. If you don't know about Robert-Houdin, then you should definitely get your hands on this book. We all borrowed from Robert-Houdin. The greatest escape-guy, Harry Houdini, actually swiped and tweaked his last name after Robert-Houdin. Houdin was the man who did away with all the glitz and glam of the magician's set. He mastered distraction by removing distractions from the stage. He did away with gas lanterns and stuck to candles. He removed the clutter and went with pure and simple.

Between Lewis' *Modern Magic* and Robert-Houdin's *Secrets*, I essentially taught myself magic. I really had to do it that way because no performing magician was going to give their secrets away to a competitor. So I read and read and re-read Lewis and Robert-Houdin. The other books and magicians were just gravy. The more I read, the more nuance I learned and was able to fold into my act. Then I'd experiment and try something, and stumble upon a new trick. I'd watch as many magicians as I could and try to figure their acts out. There were tricks that we all did, making something appear or disappear suddenly. Figuring those out wasn't difficult. The hard part was really finding a way to put your own flare or unique personality on a trick so it felt original and not merely copied out of a book or replicated from a different act.

Okay, I already teased Houdini a bit, so I may as well talk about him. Whenever I talk magic, I know people really want to hear about him. Did you meet him? What was he like? What was his trick? How did he do that?

Yes, I knew Harry. Oddly enough, he was another person who spent his childhood in Wisconsin. Apparently there must have been something in the water, because a lot of the Vaudevillians spent some time there.

Harry was fine. He was a nice kid, but he really wasn't a

magician. He tried, but he often messed up card tricks and his illusions failed. The one thing he could do, like no one else I had ever met, was get out of a pair of cuffs. That's what Beck told him right away. That's Martin Beck, remember from earlier? He was the manager of the Orpheum Circuit. Anyway, Beck kept his eye on Houdini. I guess he first saw Harry when he was nineteen and struggling at the 1893 World's Fair in Chicago. Years later, it just so happened that Beck was around in St. Paul, Minnesota, to catch an act there. Beck swung by the dressing room after the show and said, "Kid, people are paying to see the handcuff tricks and the escapes, not the magic. Do more of those things instead. In fact, come join the Orpheum." So he did.

We were each too big of a draw to be on the same bill, so we rarely were ever in the same town at the same time. Then, by the time he was really getting big, I was phasing out. It's just how it happens. His death was really sad. He made it to fifty-two, but it would have been interesting to see what else he would have done had he lived a little longer.

With that out of the way, let's turn back to me.

Being a magician requires coordination and dexterity, creativity, and mental and physical strength and endurance. It really is a full-body workout. A magician has to be aware of the audience, what they can see and what the magician doesn't want them to see, and has to balance things that are often legitimately dangerous, all while managing to pull it off looking at ease, in style, and with a flourish.

Now I'm not going to reveal my tricks here. That would be a different kind of book.

I met some like-minded magicians, like Imro Fox (Isidore Fuchs) and Ah Foon (George H. Little), and we became good friends. Whereas Houdini and I were acquaintances, Imro and George and I really connected. It likely helped that George also dabbled in shadowgraphy and Imro was a bit of a comedian. The three of us also shared a love of food and a similar sense of humor. Our get togethers almost always included Imro cooking a meal—he was once a professional chef—with George and me

sitting around him, having some wine, and amusing one another. Occasionally we'd even share trade secrets, something we didn't often do with other performers. That should tell you how much I trusted them and thought of them as friends. Later, I'd even go on to collaborate in some of my first writing with George. Sadly, Imro died in 1910, but George and I still chat now and then. He's still going strong, even though he's ten years old than me.

While I enjoyed my time with the Orpheum Circuit, eventually I started getting calls to perform on my own, and I jumped at the

opportunity. I had traveled overseas several times before, but this was an opportunity for Catherine and me to travel together on the backs of our skills and abilities. Those were challenging days because we only had ourselves to rely on. In the past, we always had someone else doing all the infrastructure and behind the scenes booking and arranging. Now it was simply us. We did it all.

It also meant we took all the credit, which was well-deserved:

"The great Clivette, assisted by Mile. Clivette will appear in a unique entertainment of magic, jugglery and 'digital silhouettes.' This act was secured in Europe by Mr. Walter who says that Clivette, as a shadowgraphist, has no superior in all Europe."

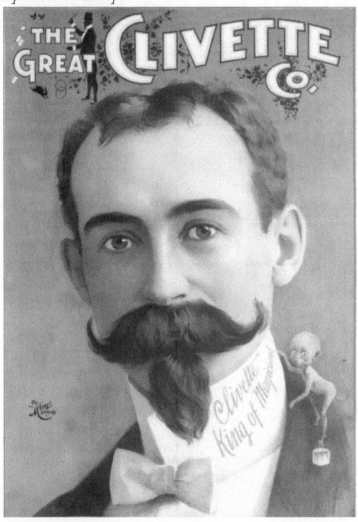

"Behold the marvelous hands which perform the most marvelous feats. In each the muscles have been developed to the highest state of perfection. The Man in Black has no superiors in this line has delighted and amazed audiences in every clime. Never mind the inclement weather. 'The Clivettes' promise you an evening's pleasure which will more than repay your time, money, and patience expended in being present. You may have been

disappointed in the past, but if you witnessed tonight's entertainment you will come away satisfied. The performance is guaranteed first class."

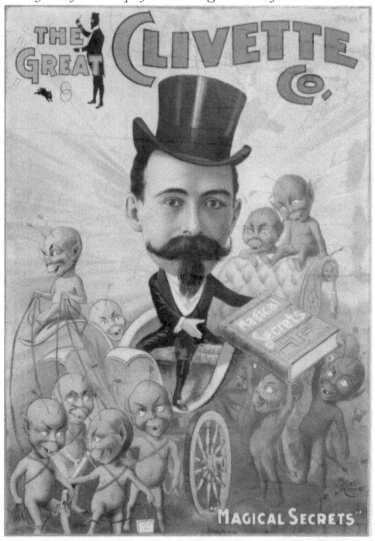

"There was a fair audience at the opera house last evening when Clivette assisted by Mme. Clivette, gave their very interesting performance. At the rise of the curtain Clivette gave an excellent exhibition of phenomenal manipulating and juggling Mme. Clivette gave a very clever turn in specialty of imitations of different people she had met in every clime. The remainder of the performance consisted of a feast of mirthful magic and astonishing diversions by Clivette some good tests in mental phenomenal."

"Prof. Clivette, juggler, necromancer, equilibrist, and finger silhouettist, as assisted by Mme. Clivette the psychological wonder of the nineteenth century, will be the next attraction, next Monday and Tuesday evening. The professor acknowledged to be a wonderful juggler, and his feats in magic are startling. Mme. Clivette who is a fine vocalist and elocutionist, renders imitations of different people she has met in various parts of the world."

"Clivette, assisted by Mme. Clivette gave a successful entertainment at the opera house last evening. Clivette is certainly a past master of his art. The first part, consisting of juggling, was a wonderful exhibition, the equal of which has probably never been seen in Fargo. He is remarkably clever in his sleight-of-hand performances and adds considerable humor to the work. He found a few things in Hon. Bill Edwards' hat that created considerable merriment. The closing part of his show, the laughable silhouettes digitaris, was a most entertaining feature. The performance will be repeated tonight with a change of programme. This man Clivette discounts Herman. His work is far superior to that the name of pseudo-namesake of the great prestidigitator, when he was here recently."

As you can see, the other benefit of going it alone was that we could entirely control the act. We didn't always have to be a magician and his assistant; we could incorporate all the other elements of our previous acts. In the process, we created something that had never been seen before. We had magic, mixed with comedy, mixed with silhouettes, combined with acrobatics and an opera singer. There was never a dull moment of the show because one or the other of us could always fill the void and vamp as necessary.

And when I say we traveled the world, I really mean we traveled the world. We performed in England (for Queen Victoria and Edward VII), India, Cuba, Australia, New Zealand, Japan, the Philippines, China, all of Europe, Russia, and of course the United States, including some of the territories that were not yet states: Oklahoma and Indian territories, New Mexico Territory, Arizona Territory, Territory of Alaska, and Territory of Hawaii.

A funny thing happens when you travel that much and get to see so much of the world. You realize how much more similar

we all are than we are different. I know wars have been fought over skin color and religion and any number of other things, but more often than not those superficial differences are because we don't take the time to really get to know the people we perceive as our enemies. Because we don't know them, it's easy to paint them as different or to remove their humanity and make them into a thing, instead of what they really are—just another human trying to make it through the day. Passing from one country to another, especially by train, I was reminded that borders are artificial inventions. Some countries, or states, use a natural border (like a river), but typically there's nothing to indicate you've passed from one country or state into another, unless there's something manmade to inform you of the transition. A sign, a wall, or armed men standing guard and checking papers.

As a traveling magician, and as minor celebrities, Catherine and I were invited into palaces and the homes of the rich, but we always made sure to walk among the regular people. I never forgot where I came from, and it was important for me to see what was beyond the façade the leaders wanted me to see. Often it was heartbreaking to see people starving and struggling, but I was also able to connect with them, and I knew that even a few small coins made a big difference in their lives. I fully appreciated how special it was for me to be able to make a living doing what I wanted, and to live so comfortably, not to mention being able to cross the oceans and see places most people only read or dreamt about.

SETTLING DOWN

Catherine and I eventually grew tired of traveling. Our whole lives, independently and together, had involved being on the move. After all that, we could have lived anywhere. Catherine grew up in Massachusetts, so it might have made sense to go there. For a while, we contemplated London. Eventually, we gave into the obvious choice. It was the one place that had a little of everything and had been calling to us all along: New York.

It's where we were married. It's where most of our friends lived. Most importantly, the city vibrated with life and art. In all our travels, we found no place quite like it, so Greenwich Village became our home and the place where we raised our daughter—Juanyta.

Before she was born in 1907, Catherine and I spent time finding our way and figuring out who we wanted to be in this part of our lives. Catherine found herself drawn to politics and civic engagements, and I tried my hand at writing, which I continued after Juanyta was born.

Being a parent changed me in ways I hadn't expected. My father died when I was so young and my existing memories of him are unreliable at best. It's not like I remembered him taking me to work with him or telling me stories. Most of my memories are of sitting at the table and hearing him chew his food. He made smacking noises. No one else at the table ate that way. One day I

imitated him, and it made my brothers laugh, so I did it again. Dad smacked me and that was the end of my budding career as a comedian. Mom was always working and then she abandoned us. Before she took off, I felt like we were always in the way, always holding her back. I used to tell myself she worked so hard to earn enough money for the family, but the more I think about it, the more I realize her husband's death set her free to do things a married woman wouldn't have been able to do. For that matter, even married women couldn't operate independently and with autonomy like she did; only a widow could have done that. To say I didn't have great role models for parenting is an understatement.

Catherine was a bit like Mom in that she had her own agenda and interests. She wasn't going to be the typical housewife who doted on the children, and I always knew that so at least it wasn't a surprise. Fortunately, since I was busy reinventing myself, I had plenty of time to raise Juanyta. In fact, in a lot of ways, my desire to write books and draw and paint were a great opportunity to teach Juanyta the same things. What better way to teach your daughter to read than to write stories and read them to her? When she was young, she didn't care what I read to her; she just liked the sound of my voice.

We'd opened a store called Soul Light Shine in Greenwich Village where we sold curiosities, It also operated as an art studio and place to sell my books. While I waited for customers, I'd read Juantya the newspaper, or the inventory for the store, or the poetry and philosophy I was dabbling in. I might have imagined it, but I swear her eyes lit up when I read her Whitman or a piece by Stephen Crane. Yes, I know that Crane is better known for things like *Red Badge of Courage* and *Maggie*, but I truly love his poetry, even if it isn't necessarily child-appropriate. We didn't know that Juantya was going to be our only child at the time, but all the time I shared with her certainly bonded us in a way that it would have been difficult to recreate if we had decided to have more children.

I took little J with me every where I went. When we went into

the market, people would call out to her and give her a piece of fruit. The baker would save her a donut or slice of bread. The butcher always had something special for her. I could feel the disappointment in the market when I went shopping without her, and I was well-liked, just not as much as she was. Everyone joked Juanyta was attached to my hip, and though she looked more like Catherine than me, she had my mannerisms. She certainly picked up on my showmanship, entrepreneurial spirit, and love for poetry (maybe she was really listening when I read to her in her crib).

As much as I taught her things, how to walk and read and all those practicalities of life, she taught me just as much. Her childlike wonder reignited my interest in the world around me. Because I was with her, I got to see the world anew through her eyes. We stared at a flickering flame. We watched the animals lounge and play at the zoo. We sprawled on the lawn, watching ants and insects climb and go about their day. She'd ask questions that I'd never considered. Sometimes I didn't have an answer, so we'd trudge down to the library. We'd gone enough times, and she'd heard me say "let's get to the bottom of it" often enough, that soon it became her phrase.

"What a precocious little girl!" people would say.

And though they thought they were paying her a compliment, Juanyta would sneer, "I am not!" Which would just make everyone laugh all the more.

What has surprised me most about my little Juanyta is how intuitive she is. Once when she was eight, we were at the market and she saw corn stalks. Juanyta had seen corn before, on and off the cob, but never the full stalk of the plant.

"What's that?" she asked.

"Corn," I said casually, not really paying her question much attention.

"That's corn?" she asked more insistently.

"Yes," I said dismissively.

"It looks like a tall grass or something," she said.

"Well, it's a plant," I sighed. "And grass is a plant, but I really

don't think they share much else in common."

I could tell she didn't like that answer. The thing was, I really didn't want to go to the library that day. I had other things I wanted to do more, and the library would eat up at least an hour of that time. Unfortunately, Juanyta had other plans.

"Let's get to the bottom of it!"

Everyone around me laughed, and off we went.

Fifty minutes later, we were hope secure in the knowledge that corn is indeed a member of the grass family. I still don't know how her little mind put that together, and how I had managed to walk the earth for nearly fifty years at that point of my life and never made that connection.

I have so many stories about Juanyta, she really and truly became my world, but the rest is for Juanyta to share, or not. It's her story to tell and maybe one day, when she gets old like me, she'll find herself interested in writing her own story for posterity. Or, maybe not? Maybe she'll just be content to live her life and enjoy it as it happens.

This is one of my favorite photos of us, all together. Happy. My two loves.

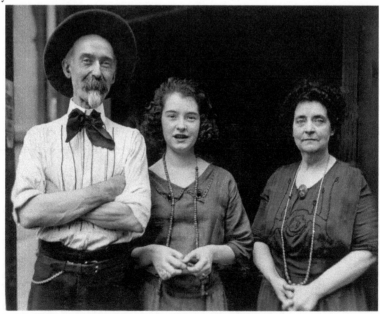

WRITING PAMPHLETS AND BOOKS

Some of these titles I've already mentioned, but for the sake of completion, I'll list them all here—more or less in order.

My first extended attempt at publishing came in collaboration with George H. Little. He had a magician magazine (I believe the first in the world?) called *Mahatma*, where he wrote about magicians and the arts and upcoming shows. I liked the idea of writing and trying out publishing, so we put our heads together and came up with *Artist Era*. It only lasted a couple issues, but it was enough to give me a taste of having to write on a deadline. When I worked for the papers, I had a sense of how that worked, but since I was just doing sketches, it never had the same kind of pressure as having to finish an entire story or article, much less an entire magazine of material. We announced *Artist Era*, and our intentions as its editors, to the world this way: "*In presenting to the public a medium devoted to various literature, science, art, and general advertising, we fully feel the great responsibility of our own duties and the momentous weight devolved upon us to satisfy our patrons. We have spared no pains to make the dress of our paper, neat, artistic, and attractive.*" Perhaps it's a little over the top and exaggerated, but that's the way of showmen. The little magazine was a vessel for us to publish and write about our friends and also an opportunity to anonymously experiment with writing. George and I both contributed a number of shorter pieces, sometimes little quips

and one-liners, and longer pieces, sometimes about manners or philosophy or a feature piece on a performer we admired. When our fun with the *Artist Era* came to an end, George decided to feature me in the *Mahatma* and wrote a very flattering piece about me and my work. It was very kind of him.

It (published 1905) was my first real exploration into creative publishing, and it's essentially a book of philosophic musings and questions I ask myself. It challenges the reader to ask themselves the same questions, to contemplate the world around them, to really take a minute to appreciate living things, great and small, and the majesty that is the natural world. People have asked me, what is "It" and my answer is: "Exactly. That's the right kind of question to be asking." The book was well received, so I wrote more. Another, much shorter work—*The Thorn Decked Prince of Peace*—is perhaps more tightly packed with words. There's less room for the thoughts and philosophy to breathe than there is in *It*, but it was no less well-received.

The Red Rag (published 1907) is an extended poem combined with philosophy. There's no art included, which I regret. I really believe that combining the arts—poetry and painting, philosophy with fiction—is the best way to engage a reader. Each of the elements compliments the other and gives the reader different entry points into the material. That's something I learned later. Next I wrote *A Tome of Liver Worse* and it's sibling *A Bouquet of Worse Liver*—though both of those are more of a traditional collection of poems instead of one long extended one.

Confessions of a Palmist (published 1908) was an extended reflection on when I tried to make a living as a palm-reader. I had opened up parlors on Lexington Avenue, and I thought I'd find clients who sincerely wanted to better themselves. Instead, what I learned was people only want to know about others. Who are they going to fall in love with? Is this person or that person cheating on them? No one, it seemed, really wanted to learn about how to be a better human being. *Confessions* is a collection of some of these stories annotated with my thoughts and struggles during this time of my life. Unlike *Red Rag*, I included

many paintings throughout *Confessions*. It is a gorgeous book. Even reviewers who didn't like the writing commented positively on the paintings inside.

Café Cackle from Dumps to Delmonicos (published 1909) is one part travel-book, another part restaurant review, and a third part memoir. It was an opportunity to reflect on some of the places I had traveled and the memorable places I had eaten. I enjoyed playing the food critic for a bit, and to keep it interesting, I wove a narrative through it to tie all the loose ends together. Is it 100% accurate? More or less.

The Thorn-Decked Prince of Peace (published 1917) was one of my last, and it is mostly philosophy and thoughts on religion. I started to realize that many of my readers don't share my sense of humor and take everything I write so seriously. Definitely not in the way I intended. I meant for much of my writing to be more tongue-in-cheek than anyone seemed to realize. Consequently, I grew tired of writing and shifted my focus on other things.

There were more, of course, but those are some of the better ones. Honestly, I'm a little embarrassed to admit there are some that I don't really remember. I wrote some poetry, some nonfiction, some fiction, and some that are a blend of all three. At first, I thought I'd write to instruct and share, much like Cody and Taylor did, but I quickly learned I could write to entertain just as well. Somewhere in that process I wrote more books than I could keep straight in my head. Some connected better with readers than others, and it was always difficult to know which one would break through and why. As much as I was able to predict how people would behave or respond to my shows, I struggled to do the same with my writing. At some point, I stopped writing for others and wrote for myself. I figured the readership would shake out one way or another. This is when I started experimenting more, even painting and playing with the form and creating my illustrations. Books were another opportunity for me to experiment with that form, too. Most importantly, for our daughter, this was something I could do at home. Writing didn't require me to travel, but if we did travel, then I could write while

abroad as well. It was truly the most flexible medium I had found for self-expression.

THE GREAT CLIVETTE, THE ARTIST

I know they say I "debuted" in 1926 as an artist with my first solo show, or maybe they'll point to the 1923 exhibition with the Greenwich Village Historical Society, or that I've been selling paintings out of my No. 1 Sheridan Square store since 1921, but it's harder than that to put a starting date on my life as an artist. I'd been drawing and painting all my life, I even created most of my own advertising posters when I was a young entertainer. So when people ask me, "Why did you turn to painting in your later life?" I don't consider it a reasonable question. The better question is, "Why did you *devote* yourself to painting in your later life?" and that's the question I'll answer.

As I've shared, I've always doodled and painted, and don't forget my time as a sketch artist and illustrator for the newspapers. Drawing and painting come naturally to me, and it has been something I've often turned to for focusing my thoughts. I also love sculpture. It may not be what people remember me for now, but at the time, I sold plenty of sculptures. When I passed through towns, whether on tour with Catherine and our show, or in my earlier days with Cody or Taylor or the Orpheum, I always looked for a studio. It's how I came to study sculpture with Rodin and painting with Whistler. I have always been inspired by the work of other artists and performers, and working with Whistler and Rodin was no exception.

James Abbot McNeil Whistler. He was always a bit of a joker with a biting sense of humor that usually caught people by surprise when they found themselves on the receiving end of his hot poker. He loved to talk art and was particularly impressed with my abilities. We spent time together in England where he often came to our shows to spend time with Catherine and me. He died in 1903, way too soon. He was nearly seventy, which is a good run, but I met him too late in life. I would have liked to have enjoyed his company for a couple more years. I always appreciated how he reinvented himself the way Cody, Taylor, and I did. For example, instead of claiming Massachusetts as his place of birth (which is written on his birth certificate), he claimed St. Petersburg, Russia and said, "I'll be born wherever I want, paperwork be damned!" I admired his work, despite his bent toward realism. My favorites of his are the ones where he veers away from realism, the ones that are fuzzier and a bit closer to my style. I'd like to think it was my influence wearing off on him, but who knows. Maybe it was a practical result of his vision blurring in old age, and he couldn't help but paint the world the way he truly saw it. Unfortunately, I never thought to ask, so I guess we'll never know. I think if you take a look at "The Bathing Posts, Brittany" (1893) and put it alongside any of my gouaches, you'll see a great deal of similarity. I'm sure Whistler would say the influence went the other way around, but I hadn't encountered that particular work of his until after my style had already been established. Perhaps we both arrived at that same point independent of each other, a sort of cosmic arrival.

And then there was Francois Auguste Rene Rodin. Sadly, I outlived him, too. Thankfully, I had more years with him because I met him earlier in life (the late 1880s), and he lived longer than Whistler's sixty-nine years (Rodin passed in 1917 at the age of seventy-seven). We met in France and then again whenever our paths intersected. Unlike my relationship with Whistler, I truly studied under Rodin. Before that, I had never dabbled in sculpture, but Rodin taught me, and I fell in love with that medium. My sculpture pieces weren't as popular as my paintings,

so I did less of them, but it was still a passion. Some of those sculptures truly captured the interest of the public, much like Rodin's "The Thinker" sculpture did. It's funny how a simple thing, a man sitting and thinking, can become so universal and admired. But, if you compare the texture in that sculpture with the knotted muscles of my "Abraham Lincoln," you'll see the debt that I owe to my teacher. The highest compliment I was ever paid came from Rodin. I painted him, and he said it was the greatest likeness of him he'd ever seen. I suspect it's because some of the energy and rawness of his sculpture, which he taught me, found its way into my paintings and he admired that style.

Of all my teachers, Rodin and Whistler were the two I spent the most time with and who had the biggest impact on me. If you look at our works side-by-side, or at least some of our work side-by-side, you will their influence on my work, but you won't ever confuse a Clivette for a Rodin or a Whistler. More importantly, we were friends, colleagues. We were in the same conversation. We each had our own dominant side of that conversation yet harmonized with the others. Does that make sense? I hope you get what I mean.

There were other tutors and people I met to whom I owe a debt for my artistic success. For a short time, I even studied at the Art Students League—which was within walking distance of where I lived. It held workshops and classes for painters. There I met and learned from La Farge, Chase, and Twachtman. John La Farge and I connected on art, but also on writing books and our travels to Asia. He was frequently tied up in creating stained glass and arguing with Tiffany over who owned the patent for the process. He lived in Greenwich Village with us and was a great neighbor until he died in 1910. William Merritt Chase had his own school of art and was only at the League for a short time. He saw what I was doing and encouraged me to keep pushing. Then there was John Henry Twachtman, who I wish I had more time with. He passed a year or so after I met him, in 1902. He was the one who really taught me the art of lithography. While I had designed my posters previously, I didn't have the skill or

ability to reproduce them myself and had always relied on a printer. I admired Twachtman's art, but appreciated his lithography lessons even more.

You also have to remember that the art world was constantly being rocked to its knees in that day. First, there was the innovation of the daguerreotype, which practically rendered realistic painting obsolete. The saving grace was that taking a daguerreotype was time consuming and the subject had to remain perfectly still because any movement caused the image to blur. Once photography evolved to the point of being able to capture a horse in full gallop—thank you Muybridge—then blurring was no longer a barrier to a faithful re-creation of the physical world. That was fine for me, aside from my sketch days at the papers, as I never really cared for art that simply reproduced what the artist saw. I was perfectly content to let photography capture the world as it was. I saw no need to painstakingly recreate what was physically, and objectively, there. Instead, I wanted to capture the *feeling* and *emotion* of being there and witnessing it. Whether that be a fish or animal, or a landscape, or a person. This remains something photography, or any kind of mechanical reproduction, cannot deliver.

Our first apartment in Greenwich was located at 1 Sheridan Square, then we moved to West Broadway, and finally to 92 Fifth Avenue. We always had a studio, a gallery, and a storefront. Sometimes we called it Art Mecca or Bazaar de Junk or Soul Light Shine, or some other name meant to imply whimsy and intrigue. We always had a place for me to work and a shop for us to sell art and pamphlets and books and anything else we felt like selling. Little Juanyta grew up amidst the chaos and excitement of Greenwich Village and all the people who frequented the shop, and Catherine was close to all the officials and city administrators she needed to be.

It's difficult to capture the excitement of that time and place. The area has simmered down considerably since. Back then, it was like a magnet. We couldn't resist its pull. Now, as things have slowed down for us, we could escape its orbit if we wished, but we have so many friends here and other reasons to remain. It likely helps that we're older and don't require so much excitement in our lives. But initially, that's why we came and why we stayed.

ELECTRIC LIGHT CHANGED EVERYTHING

Some inventions and events are so momentous, they become ubiquitous to the point of being taken for granted. We become so used to a thing existing that we forget the time that predates the thing being part of our world. One of those things for me was electric light.

During my lifetime, fireplaces went from being a necessity as the primary a source of warmth, the cooking place, the source of light, and the place for families to gather to something intended merely for providing atmosphere or intimacy. The timeline of this shift depends widely on where you lived, but in Wisconsin and Wyoming, fireplaces were the norm, and candles were the only way to be able to read or write away from the glow of the main fire. I remember the nights in December and January were so long, and I spent so many nights reading by the humble glow of candles. It wasn't until I moved to New York that I truly experienced electric light and how it extended the day long into the night.

Edison first lit up Manhattan sometime around 1882. I remember being thirteen or fourteen and reading about it in the paper. His grand Pearl Street experiment appeared to be a massive stunt (not so different from the kind Taylor and Cody and I would have attempted), but from what I recall, it went off without a hitch and soon the use of electricity grew from Pearl

Street outward like an octopus uncoiling its tentacles. By the time Catherine and I moved to New York, electric light was the norm.

Electric light dramatically changed the way living spaces could be used because lights were brighter, longer lasting, required less attention and care. Even more useful, electric lights could be used in different rooms—the way a fireplace could not.

For an artist, electric light changed everything. Before reliable light sources, we were limited by the number of hours of light in a day, and as the sun moves, the shadows shift. This meant I had to set up my easel in the same space every day and be ready to paint at precisely the same time each day. To accommodate the shifting sun, I would find an isolated place that was unlikely to be disturbed by anyone but me, and I'd mark the ground with rocks or chalk. If it rained, or was overcast, I lost the day. When working by candlelight, or oil lamp, the light moved and flickered. It had its own charm and certainly gave a warmth to the subject matter that wouldn't have been there otherwise, but flickering light presented its own challenges. Candles burned down and changed the shadow. Oil lamps needed to be refilled. Furthermore, I was at the whim of the placement of the candle or oil lamp. They required a flat surface, or a hanger to use them.

But electric light?

It was steady, reliable, and consistent. It didn't fix the problem of painting nature, but it certainly revolutionized the world of indoor painting. Still-life and portraiture were dramatically changed by good, dependable lighting. It was truly a marvel. Electric light also presented new opportunities for depictions of cities at night, all lit up and glowing.

I confess to not understanding how Edison and Tesla's magic works, but I don't have to understand how it works to benefit directly from it. As a person who needs little sleep, there isn't a better gift that I could imagine than the ability to paint and read at any time of the day or night, regardless of season or weather.

GREENWICH VILLAGE

You've already gotten a taste of this, from what I wrote about Juanyta's childhood, but to really understand what Greenwich was like, and the context of the world I was writing and painting in, you really need more space dedicated to just that. So, here's that.

We should probably get some basics out of the way first. When people talk about Greenwich Village, they're typically talking about the blocks within the boundaries of 14th Street (north), Broadway (east), Houston (south), and the Hudson River (west). The Village proper has grown and shrunk over time, but in general it's about a quarter square mile. In that little space, there are all kinds of poets, writers, artists, shops, galleries, theatres, but we're also mashed up with warehouses and meatpacking and things decidedly less artsy (or Bohemian, if you prefer).

Before we moved in, Greenwich was a place where folks like Mark Twain, Henry James, Stephen Crane, and Edith Wharton frequented, but after the financial collapses in the 1890s, a lot of those people moved out. Housing became cheaper, and the Village became a place where immigrants could now afford to live. The cheap rent definitely attracted us, but we were more drawn to the eclectic collection of people from all around the world who called the area home. It was almost like this little area

was an encapsulation of the world, and it was right outside our front door. On a trip to the market, you'd hear so many different languages spoken, and even the creation of new, pidgin, languages, that allowed communication between the different groups.

I loved it and embraced everything about living there, and everyone knew me and my family. I spoke several of the languages that were spoken in the Village, so I could easily work as translator and frequently did just that. The papers even went so far as to called me the "Father of Greenwich Village." Later, they'd give me credit for helping to regrow the arts district of the area that had virtually disappeared after the financial collapses of the previous century.

And then The War came.

I know the papers say it didn't come to America until 1917, when the country officially dropped the pretense of neutrality, but the war came to the Village way before then. I was surrounded by Germans, Austria-Hungarians, French, Russians, Brits, Serbians, Poles, Czech's, Slavs, and more. All these people, my neighbors, my fellow artisans, had family back in their home countries. They were trying to find a way to bring people from the Old Country to the Village while struggling to pay their own livelihood. As the war went on, it became more and more difficult for anyone to leave Europe and enter the US. Between the Immigration Act and the literacy tests, fees, bureaucracy, and all the other obstacles put in their way, it was near impossible for my friends to bring their families to join them here. In other parts of the country, even in other parts of the city, people fleeing the war from abroad were seen as lazy and some of their shops were burglarized or vandalized. It was terrible. But in the Village, we supported one another. Sofas were used by cousins until they could find a permanent bed, and we did what we could.

After the war, it got better, but people still struggled. Then, of course, there was the next financial collapse. So, in many ways our time was bookended by difficult times for the Village. Thankfully, we were very fortunate to never suffer some of the

hardships our neighbors did and were often able to help when they needed it.

When times got tough for our friends and neighbors, we hired many of them to work at whatever business we had at the time. We almost always had space for a clerk, or guide, and taught several of our neighbors how to speak English to better serve customers.

That was the Greenwich Village that we lived in. It was a living, breathing, evolving entity whose sum was greater than its parts. Each person or store or theatre or artist supported the Village and made it stronger and better.

WOODROW WILSON AND ABRAHAM LINCOLN

I don't want to dwell too much on The War, but something has to be said about Woodrow Wilson. I hate to sound like sour grapes because Wilson won the election and my guy didn't, but I struggle to see what anyone finds likeable in him. In all fairness, he only won 42% of the popular vote, so he wasn't even that well liked. Still, people continue to get swept in the "he got us through the war" argument and forget that 58% of the voters did not vote for him. But, Wilson's 42% was still more than Taft's (the incumbent) 23%, or Teddy Roosevelt's 27%. We likely have Roosevelt's Progressive party to thank for Wilson's victory. Had they not entered the race, Taft would likely have won. Or, for that matter, if Taft had bowed out, Roosevelt probably would have been our president.

But, back to Mr. Wilson.

Lest we forget, Wilson was a racist. He fired blacks left and right. When our nation was working towards ending segregation, he set the movement back years and years, and maybe even decades. When World War I broke out, we had able-bodied men wanting to fight for the country, but Wilson denied them based on the color of their skin. There were black men and women who wanted to serve the government and become part of the federal system, and Wilson held them down. Some Wilson sympathizers point out that he grew up in the South and lived through the Civil

War, but you'd think by 1912, nearly fifty years after the Civil War was over, that his thinking and mindset would have evolved. I know my mind certainly had evolved over my years, and I don't hold many of the same beliefs I did when I was younger.

Wilson kept us out of the war until the very end. That you can definitely say. What's more difficult to say is whether this was a good thing or not. How long did he leave our European friends and allies to fend for themselves, and how many aggressions did he allow our military to tolerate from the German submarines before taking action? He ignored Germany's attempt to rile Mexico against us on our southern border. As our nation sat out the war, I was surrounded by European friends and neighbors. I grieved with them as they grieved for their families and hometowns overseas. I realize I'm biased, and I would not have wanted to be the one to decide to send soldiers to the front to fight, but there are too many questions about Wilson's time in office and his motives that I distrust.

My other big question about Wilson is in reference to his physical and mental fitness. How able-bodied (or minded) was he in his final term? Who was really making decisions while he was incapacitated? He suffered a serious stroke, his left side was paralyzed, and he was partially blind in his right eye. Even the president's medical advisor said Wilson struggled with "disorders of emotion, impaired impulse control, and defective judgment." Is that the kind of person you want running the country? And yet, he didn't step down or let Vice President Marshall step in. So, from 1919 when he had the stroke until 1921 when his presidential term ended, who was running the show?

The whole situation bothered me to no end, so, I painted a picture of him. I called the painting "Salome" and exhibited it at the Society of Independent Artists at the Waldorf Astoria Hotel. The painting showed Wilson's head on a tray, which was being held by a strong black hand and arm. The background was a turbulent sea. Surprisingly, it turned out to be a highly controversial piece. I thought the message was pretty clear, but a lot of people didn't understand it. While the controversy was

good for business, as it always is, it was disarming to me how ill-informed the public was. When no one bought it—perhaps because no one could afford the $10,000 it was valued at—I proudly displayed it in our little Art Mecca.

Imagine my surprise when I heard a pistol shot outside the store and then breaking glass. I ran to the street but was too late to find the culprit. Thankfully, the bullet only broke the window and then the glass of the frame but didn't damage the painting. I knew my art was provocative, but I never dreamed it would cause such violence. After that, I sold the painting but sadly, I don't have a photo of it. I do, however, have a photograph of the storefront after the shooting. You can see the bullet hole in the upper right corner of the window.

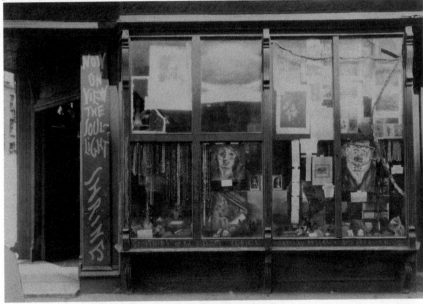

My statue of Lincoln also caused a stir but not to the level of inciting violence.

I suppose people were surprised that I chose to portray the president in the nude, but I truly don't understand what the hub-bub was about. Not only is nakedness natural, it's a staple of the art world. We've been sculpting and painting nudes to study the human form for centuries. My motivation for sculpting the nude Lincoln was sincere and true. I wanted to celebrate the physical

strength of Abraham Lincoln that was so often buried under his black suit and dour features. He was a strong man who used to split rails and chop timber before becoming known for his skills as a diplomat and orator. That's all I hoped to depict: a perspective of the president that was forgotten because it was overshadowed by the other aspects of his life and presidency.

I mean, I called it "Rail Splitter" for a reason.

The human form is a beautiful thing, and Lincoln's is no exception. If anything, he is even more beautiful because he sought to hide his physical prowess to be less intimidating, and instead relied on speech and reason. I think it's important to be reminded that beneath the pomp and circumstance and policy and titles, presidents are just men. Strip away their clothing and they look like you or me.

There were two basic story arcs that ran in the papers. It's funny how unoriginal newspapers can be. The first way to present

the story of the statue, which seemed to be the more common one, ran without a photo. Apparently, that would have been too scandalous!

There was one, without a photo that ran and buried the story in the larger "New York at Large" column. It didn't include an image, but at least it took some time to capture my intention behind the sculpture: *"Speaking of bronze statues, Greenwich Village's 'man in black' has fashioned one of Abraham Lincoln in the nude--and what is more, he has gotten it on display in the Aisnslee Galleries on Fifth Avenue. The man in black is Merton Clivette, 80-year-old painter and sculptor, writer, former magician and circus performer, and one of the familiar characters of the Village. His Lincoln likeness, about 30 inches high, shows Lincoln gaunt and emaciated but knottily-muscled, leaning on an axe-handle. The ankles are crossed and the head is tilted upward. The statue is called 'The Rail Splitter,' Clivette avers that every other artist who has attempted to express a conception of Lincoln has sought to make ill-fitting clothes tell the story of physical suffering which can be revealed only by an undraped figure."*

The other storyline ran with headlines like "Astounding Statue of Lincoln," which is really more of a caption than an article title. At least they included an image of the statue: *"'This is one of the most astounding statues... it has the simplicity and forthrightness of a medieval conception of an early Christian martyr... it has expressed the inward ideals of Lincoln in terms of the physical,' so said George H. Ainslie, right, president of one of the oldest art firms in America, in accepting this bronze of a nude Lincoln. The sculptor, shown at the left, is 80-year old Merton Clivette, well known to New York's Greenwich Villagers."*

I know that once the artist creates something, it's out of his hands. It's up to the public to make meaning of that art. Still, it's disappointing to see such a lack of creativity and critical thinking. First, with the Woodrow Wilson painting. I guess I should be honored that it moved someone to violence, but I'd really much rather the man—I have no doubt it was a thuggish, stupid man— came into my shop and started a conversation with me. Surely we could have engaged in a reasonable discussion, and I could have challenged some of his preconceived notions. Maybe he would

have taught me something in the process. Instead, I got a bullet hole and broken glass. Then, with the Lincoln statue, all the attention was on his lack of clothing. It was not the point or my intention to cheaply inspire headlines from outrage to the nakedness; it was *supposed* to get people to see their heroes in a new way, a more primitive, more basic, more universal way.

I guess that's all I have to say about that, except to add: surely this has to be the first (and last) time that Woodrow Wilson and Abraham Lincoln have shared space on the page. Aside from the office they shared, I can't think of anything else that binds them.

ARTHUR CONAN DOYLE

I wasn't sure where to put this, because technically it happened sooner than the general trajectory here, and it also took place later than this point. It didn't make sense to mention Doyle earlier, and he's a rather insignificant footnote later in my life, so this feels like a good landing place for this story. It's another topic that I get asked about a lot, I suspect mainly because of Doyle's celebrity and everyone wants to know about the creator of Sherlock Holmes.

In truth, he wasn't as smart as you'd think he was. I mean, Sherlock Holmes was clearly a genius, so you'd assume the author behind Holmes would be as well. And yet, I'd struggle to call Arthur Conan Doyle anything of the sort.

I met him back in the early 1890s when I was doing my spiritualist shows. He was fascinated and convinced I could convene with the spirits. Eventually we began to chat and became friendly, and then I told him the truth about occultism. I shared the basic ideas behind how it worked, taught him to read people, and I kind of thought that was the end of it. I figured he'd write it off as a novelty and be glad for the information. After that, we bumped into one another occasionally when he was on a speaking tour, or if I was in Scotland or England, or when he was visiting the states. He always seemed nice.

He never shared anything about Sherlock Holmes with me.

But, then again, I never asked. The novelty of him being an author didn't really interest me. I had met other authors before and was soon to start writing my own books. It probably also didn't help I really had no interest in mystery writing. I enjoyed only small amounts of fiction, and there were so many books to learn from that I didn't have much patience or time for made up things.

One day I ran into Houdini, and he mentioned Doyle. Apparently they had become friends.

"That's funny," I said. "I know him. Small world and all that."

"The guy insists I'm magic!" Houdini said.

"Oh?"

"It doesn't matter if I show him where I keep my picks or keys, or how I do the trick," Houdini said, laughing, but clearly a little frustrated. "He still insists I have actual, verifiable magical powers."

"But you can't even master card tricks," I said, which was a bit mean, but I knew Houdini wouldn't take it personally.

He glared at me good naturedly. "Yes, yes. I don't know to how convince him otherwise."

"Does it matter?" I asked.

"It should!" Houdini said. "He's a doctor!"

"It's funny," I said. "I had the same problem with him," and I relayed the rest of the story to him.

"Ridiculous!" Houdini said. "He's in some club, the Psychical Research group? And the Ghost Club! He runs around claiming he can see and expel poltergeists."

I shrugged, not really sure what else to say.

"I can't associate with him," said Houdini. "It's embarrassing."

"What if we both talk to him?"

We found a time when we'd all be in the same town, found a quiet place to dine, and then set upon him. The poor guy was ambushed and didn't say a word until we were done.

"You may deny it," said Doyle, "but that doesn't mean it isn't true. You," he pointed at Houdini, "are magical. You contain psychic powers. You just do. There's no other way to explain it."

Houdini started to interrupt, but Doyle hushed him.

"No, no, I sat here silently while you two had your go at me. Now it's my turn," Doyle said, and then turned to me. "And you, I know you think this is just a sideshow gimmick, but when you do it, when I watched you, there was energy swirling around that you must not be able to sense. It's real."

I laughed. "Then I'm one hell of a showman. Even more convincing than I thought."

"If I had magical powers, why would I keep keys in the heels of my shoes? Or so carefully craft a crate so that it appears solid, but I can lift the pieces if I need to escape?"

"Maybe because your powers make you uncomfortable?" Doyle tried.

We started to interject, but he cut us off again.

"Or maybe you just don't believe in yourselves," Doyle finished.

Houdini and I looked at each other, and I could see the look of resignation in his eyes. This was the last we spoke of spiritualism, or magic, or anything resembling the dark arts together. It didn't stop Doyle from running seances, trying to contact spirits, and "researching" the spirit world. Heck, he even wrote a book and published it in 1924 and 1926, the two-volume *The History of Spiritualism*. It's unlikely to surprise you, but he didn't mention me in it. I did hear that after Houdini died in 1926, Doyle claimed to have contacted him from the spirit realm. I couldn't help but laugh. Then Doyle died four years later in 1930. So, if there is a spirit world, then I guess they're probably having a good laugh, too.

This all took place, I think in 1921, when Houdini was just forty-seven and Doyle was sixty-two. They thought I was the oldest, because back then I claimed to be seventy-three—twenty years older than I actually was—and the subject never came up in our conversation. I never bothered to correct their assumption that I was the old man in the room. I can't help but wonder if Doyle's desire for eternal life was a direct result of his getting nearer and nearer to the grave. Maybe his mind was softened by

old age, and he was grasping at straws. Maybe as a young man, he would've mocked or made fun of someone who believed as he did as an old man. Then again, I had first taught him my tricks years ago and somehow he selectively forgot that they were just that—tricks. Manipulations. Ways to read and, embarrassingly, prey on people's desire for answers and connection to loved ones who had passed. Despite my reminders, he continued to insist it was all real.

Not to hold myself up as an example, but here I am, an old man myself, and I haven't succumbed to such vulnerabilities. I've seen my friends and acquaintances die—Taylor (1891), Twain (1910), Cody (1917), Houdini (1926), Doyle (1930), and many other less famous friends—and yet I'm still as able-minded and able-bodied as I was when I was younger. It is possible that I'm just lucky or too strong-willed to be convinced by something I have no evidence for.

GOUACHES

With the Doyle business out of the way, I can get back to painting. I loved painting in all kinds of styles, but I'm probably best known for my gouaches. What's a gouache? First, they're severely underappreciated. When people think painting, they think watercolor and oils, sometimes acrylics, but rarely, if ever, do I hear someone mention gouaches. I'd say they've "fallen out of vogue," but I don't know they were ever "in vogue" for that to happen, at least, not with the casual public.

What's not well known is that many of the famous artists created a gouache—the public just doesn't know it. Vincent van Gogh. William Turner. Albert Beck Wenzell. Edgar Degas. Camille Pissarro. John Singer Sargent. Thomas Moran. Valentin Serov. This young upstart named Salvador Dalí. And many more.

In short, a gouache is kind of like a watercolor. There are technical differences, I won't bore you with those, but the main difference is that a gouache dries opaque, and the colors are brighter dry than when they're wet. To the layperson, that means you don't see the layers bleed through like you do with watercolors and the colors are vivid and beautiful. It also means, unlike oils, gouaches dry so they're less susceptible to damage from people touching them. To the artist, it means it can be hard to match colors if you go back later to do touch-up work, because until the colors are completely dry, you don't really know—

except through experience and experimentation—how the piece will dry. It also means you can go back and, with a little water, touch and retouch your work until you're satisfied.

My solution to all these problems was to paint fast and aggressively. Get in and get out. Not only did it serve the practical purpose of working with gouaches, but it also forced me to capture the essence and initial impulse of the subject matter. For me, it was perfect. It's what I was hoping to capture in the first place—something the camera couldn't—the immediate reaction, the blink of an eye. Nature doesn't hold still, and neither should a painting. It should capture the energy and movement and excitement and vibrancy of life. I did the same with people, whether they be performers, or vamps, or people in the street, or whomever caught my attention. Life, nature or human, has an energy that is lost in most paintings and certainly in photography. I'm simply trying to capture it in my work. That's what I hope people see in my art.

Self Portrait in Red Shirt, ca 1925

Ocean Fish 213, ca 1925

Snake Killer, ca 1925

Blizzard Rider, ca 1925

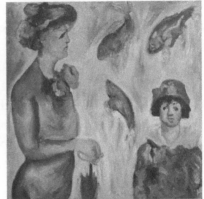

Outriding the Blizzard, ca 1927

Woman and Child at the Aquarium 134, ca 1925

My critics claimed I painted quickly only to produce many paintings. While that was a result of my process, it certainly was not my intent. It broke my heart a little to read the San Francisco critic Junius Cravens call my exhibit, *"superficial"* and *"sensationalist."* Or when the Oakland *Tribune* wrote, *"We are of the opinion that Clivette is not an artist; perhaps not even a good faker."* At least they came around to confess, *"we must admire his grit."* Sadly, they followed that statement up with, *"or whatever prompts an octogenarian with such a strange and varied past—and artistic past—to spread his 'art' over the world, modestly proclaiming to said world in lavishly*

prepared advertising sheets that he is the greatest artist same said world has ever produced." Yet, their city happily held my exhibition and did not shy away from the commission when work was sold. And, I'm sure their papers and magazines did not turn away profits from the papers they sold due to the attention I generated for them.

I will confess, my tactics are unique and unlike other artists. How could they not be? We are all unique and have our own approaches. My past is in the performing arts and promotion, of course that would bleed over into this current stage of my career. I believe my confidence and transparency are the things that make them uncomfortable. Maybe they want someone to passively display their art without emotion? Maybe they want someone to be humble and grovel before the critics? Well, that is not me. Never has been. I speak my mind, and I am proud of the work I do.

Not that money determines art by any means, but certainly the bottom line indicates something as a rebuke to my critics, does it not? Certainly one person could be duped or tricked into buying something, but to persuade hundreds to part with their hard-earned money to purchase a piece of decorate art? Now that would truly be a trick. By the time I was mentioned in *Time Magazine* in 1927, I had already sold thirty or more, and not for insubstantial sums—the smaller pieces selling for $200 and the larger ones ten times that. It's one thing to take a dime from a person, convincing them they'd see something fabulous and magical, but my critics are accusing me of performing the same deception, only for a much greater fee.

Money and acclaim aside, what is art and who gets to decide? If someone, trained or not, buys a painting because it moves them, is that not art? How long does a painting have to hang on a wall before it can be recognized as great? Does the artist have to be long dead? Must an artist suffer and struggle in order to be perceived as "serious" and "true"? I think the thing that made my critics most uncomfortable was that I was proud of who I was, spoke freely, and was able to survive by selling my paintings.

More than survive, I lived comfortably and supported my family. And why shouldn't I? Isn't that the dream? To be able to do what you love and live happily?

Finally, and not to be snobbish, but who are the Californians to be taste makers? What do they know of fashion or style or art? When you're accepted and loved in New York and Paris—as I am—surely, you're doing something right. But it's always the squeaky wheel that gets the grease. Somehow it doesn't matter how many people say that they love your work, the one contrary voice is the one you hear the loudest and demands the most attention.

CAREER ARTIST

Though I'm best known for my gouaches, I also worked in oil and tempera and drew in pen and pencil. If there was a medium to try, I'd try it. How many paintings and drawings did I create? That would be impossible to say. Many, many. Thousands? That's probably right. Some I gave away, some I sold, some never left the studio. The best compliment I ever received from a critic was, "*Regardless of form or format, you always know a Clivette because of the color, composition, and use of line.*" I love that. There are so many artists who aspire to attempt to capture the style of the moment, or to emulate their influences, and few ever attain the universal ability to immediately be recognized by their works—much less whether it's in oil, gouache, sculpture, pen, or pencil. If I have achieved nothing else in my life, this is enough.

For inspiration, I stepped outside and looked around. A snide critic dubbed me the "*painter of the mob.*" Rather than let his intended insult land, I ran with it. I even gave lectures about painting "the mob." I mean, what is the mob anyway? It's just the common man and woman. They are the people you walk by on the street, have coffee with, bump into at the market, and talk with on the train. They are not the glorified elite who look down on us from their office buildings. Surely the common man and woman are worthy of becoming immortalized in paint, are they not?

Did I paint vamps? Yes.

Did I paint bohemians? Of course.

Did I paint women of the night? Yes.

Fat people? Yes.

Fighters? Yes.

Day laborers? Of course.

Truly, everything outside my window was my subject matter. Some critics didn't approve, but not all art is for everyone. I found the world and people around me continually fascinating and there wasn't enough paint or pen, to say nothing of time, in the world to capture it all. If being reminded of the people overlooked or looked down on made someone uncomfortable, then too bad. I saw beauty and life in the ordinary and did my best to capture that. Sometimes it was in paint, other times it was in clay. Sometimes it was a matter of the material I had nearby when I was inspired, and others a certain subject simply called for a specific medium.

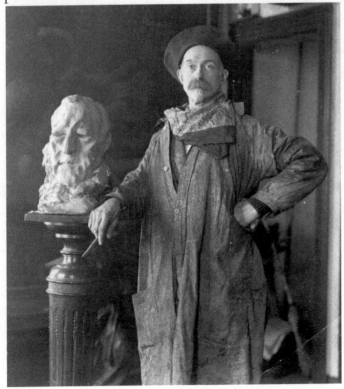

Art took me around the world again, so clearly I was doing something right.

A gallery in Oklahoma City exhibited my work in 1923.

My adoptive home of New York embraced and regularly exhibited my work.

I had a solo show in Paris in 1927.

INVITATION

EXPOSITION D'ŒUVRES

DU PEINTRE AMÉRICAIN

CLIVETTE

du Samedi 2 au Samedi 16 Juillet 1927

de 10 heures à 18 heures (sauf le dimanche et la matinée du lundi)

CHEZ

MM. BERNHEIM-JEUNE, EDITEURS d'ART

83, rue du Faubourg Saint-Honoré, PARIS (VIIIᵉ)

There were shows in Detroit, Cincinnati, Milwaukee, Louisville, Philadelphia, and all around the United States.

Of course, California exhibited me—Oakland, San Francisco, Los Angeles, Los Gatos, San Diego—shunned me, and then welcomed me back for more.

Other exhibitions in Europe.

Perhaps my proudest moment was when George Hellman embraced my work. Hellman has an incredible eye for talent—and I'm not just saying that because he liked my work. He makes a living because of it. The man is an art collector and dealer, not to mention an author and a bit of an artist himself. When he puts together recommendations—artists to look for—people listen. The art collecting and museum world eagerly awaits and counts

on his recommendations. Imagine my surprise when I was the only American to be given a special article and included in the company with: Picasso, Cezanne, Matisse, Derain, Gauguin, and Van Gogh.

I know that an artist shouldn't rely on external validation for a measure of self-worth or confidence, but Hellman's stamp of approval meant far more than I could have ever anticipated.

DEATH OF FRIENDS

Sixty-two is not all that old, many people live longer, but after a while you begin to feel the age as your body is unable to do the things you once did. Not that I ever had any desire to return to the slack wire act or acrobatics after I retired and moved onto writing and painting, but sometimes it's still a shock to look in the mirror and see what time has done to my face. For so long, I pretended to be older than I was. I grew mustaches as soon as I could. Sometimes I even bleached portions of my hair white to appear older. But it was always a prop, like makeup, a distraction for the stage or promotion. Now that my hair is legitimately white and my body is old, I wish I could perform a trick to reverse it.

The last year has been particularly difficult. The best the doctors can tell me is that I have a "lingering illness." Is there anything less satisfying than receiving a non-diagnosis like that? They used x-rays and radiation treatments after finding a tumor in my abdomen, but I still feel myself fading and reflecting on the friends who have passed before me. The obituary section of the paper is almost a "who's who" of the people I used to know. Some are famous, some not. Some were neighbors, some dear friends, and plenty are acquaintances I crossed paths with for just a short time.

I know my time here isn't done yet, because my life isn't flashing before my eyes. It's more of a slow scroll through the

various acts of my life. I see the forty-five or so books I wrote sitting on the shelf but remember only a fraction of them. I flip through the scrapbooks of promotional posters. Occasionally there's one that I don't remember, and I have to read it carefully to recall what my act was and at what point in my life it was from. Over time, I've saved everything I could, not because I am vain and like seeing my name in print, but because I always wanted to remember every act. Every phase of my life. And now I struggle, even with these artifacts at my fingertips, to remember some of the most momentous acts of my life.

I've never regretted paying for the service that searched the papers all across the country for my name. I've kept all the clippings. Some are mere mentions, "Tonight! Clivette!" and others are detailed reviews, or longer articles in magazines. I wish I could tell you how much I paid for the service, but it's been long enough ago that I don't remember. I will tell you that I'd pay twice that again and still make the same decision to hire them. At the time, it was a whimsy, an amusement, but now, it's a portal back in time. When I'm writing a section for this book, and I need inspiration, or a reminder, I flip through those clippings and find it. It's also an opportunity to see my life through a different lens. How many people have the luxury of a third person perspective following them around? I never could have anticipated how much comfort these clippings would bring me in my old age.

When I'm gone, I hope they take my ashes to the top of the Statue of Liberty and cast them east, north, west, and south to the eternal, for I am an eternalist. That's not too grand a gesture, is it?

Maybe I'll actually live to be the octogenarian I once claimed to be. Wouldn't that be something? If not, how can I complain? It's been a great life, and I've done everything I've wanted. Seen so much of the world. Most importantly, I've seen my daughter grow into an adult that I am so proud of. She carries on the best of her mother and me. Juanyta inherited stubbornness from both of us, eloquence from her mother, self-confidence and self-promotion from me, and other traits that are a blend of the two

of us. If I were to have died yesterday, between the money I've saved from selling paintings, and all the art that's left to sell, my Catherine and Juanyta will be financially taken care of. It brings me some comfort knowing I can leave them this final gift, this final act of love.

POSTSCRIPT FROM CATHERINE CLIVETTE

Merton Cook Clivette died on Friday, May 8, 1931, and the world mourned. Obituaries poured out of every newspaper. Very few of them ran the same, stock, pre-canned, piece which was common at the time. Typically one obituary would run in every paper, so if you read it in Indianapolis and New York City and Miami, they were identical. Everyone had the same facts and story. But, perhaps because of how unique Clivette was, and how he visited nearly every city in the United States (and many outside of the US), every paper had something original to say. Some commented on his age, like the one in the *Art News* that mentioned: *"to the surprise of many also Clivette was only 62 years of age."* Another mentioned a piece of trivia I had forgotten: *"Former Governor William Sulzer, for whom Mr. Clivette was once campaign manager, delivered the eulogy."* Of course I remember Sulzer, but I really don't remember Clivette being his campaign manager. My Clivette was always so busy, spinning so many plates, that he often failed to mention all the projects he was working on. Getting a friend elected may have seemed unimportant and not worth mentioning.

Of the obituaries, I think none would have made him prouder than the piece the *New York Times* ran Saturday, May 9, 1931, because it really captured the essence of the Clivette my Merton

presented to the world. We reprint it here with permission:

Merton Clivette, artist, "Father of Greenwich Village," writer, lecturer and dabbler in the occult, one of the most widely known characters in the Village, died yesterday at 92 Fifth Avenue, his home in recent years. He had long been ill. Mr. Clivette, who had also been a store keeper, tight rope performer, circus rider and acrobat, was 62 years old.

Born in Wisconsin on June 11, 1868, Mr. Clivette, who described himself as 'a superb Baron Munchausen,' used to say that he first saw the light of day aboard a boat on the Indian Ocean. At any rate, he added, he knew American Indians in his youth, and highwaymen too. In fact, he once made the claim on a poster, shown at one of his art exhibits, that he had been an Indian himself, but this was discredited by his friends, who were legion in the Village, where he lived nearly forty years.

He was a tight rope walker, acrobat and knife juggler in a traveling circus for a time. He tossed six knives at once. In his Western days, he said, he had many fights with man and beast. He declared that he had more than 200 knife and bullet wound sin his back.

He wrote forty-five books, he said, about his philosophy, business politics, literature and music. As a psychic, he recounted that he had been consulted by Queen Victoria, King Edward, Lord Kitchener, Gladstone and other notables. He crossed the Atlantic thirty-two times. He also said he was a political agitator in the Far East.

He referred to himself as a 'genius' and, if his works weren't always liberally lauded in the Village, they were, later on, uptown. In 1927 he exhibited many of his portraits and other paintings in the New Art Gallery in Madison Avenue and received the praise of critics. He had 'arrived,' it was said. One of his portraits was of himself, with flaring mustachios and white beard, pointed.

Mr. Clivette studied painting under Chase, La Farge and others, and sculpture under Rodin. He also studied at the Art Students' League. He often exhibited in Paris and was said to be the only man who had a painting hanging in the Luxembourg Galleries while still alive. He had a studio for years at 1 Sheridan Square, where he ran a curio, print and painting shop that was famous. Later he painted and lived at 64 Washington Square South. He also had a studio for years in Stamford, Conn.

Many noted persons knew Mr. Clivette, and spent evenings with him as

he retold his adventures, past, present, future and hypothetical. He was greatly beloved by all.

Mrs. Catherine Parker Clivette, civic leader and president of the Society for the Prevention of Unjust Convictions and the Greenwich Village Historical Society, his widow, survives him, as does a daughter Miss Juanyta Clivette.

During his lifetime, he called himself, or others called him, a variety of things:
An Umbramania.
An Eternalist.
Professor Clivette.
A necromancer.
Finger silhouettist.
Shadowgraphist.
Magician.
An equilibrist.
Clairvoyant.
Juggler.
Equilibrist.
Mind-reader.
Comedian.
Hypnotist.
A pantomimist.
An actor.
Tight-rope walker.
A knife-juggler.
Prestidigitator.
Lecturer.
Painter.
Author.
Vaudevillian.
Political agitator.
A mysterious stranger.

I'll add two more to the list: husband and father.

What more is there to say? He was loved. *Is* loved. I have never believed in the spirit-world he and I used to entertain audiences, but I see him everywhere. He is present in his art and work surrounding me still; I see him in the little things that remind me of him. The trinkets he left haphazardly around. The smile on my daughter's face. Perhaps the greatest gift he gave me, and her, was the enthusiasm and curiosity he approached life with every day. Every day was a gift to him. When I feel the sadness settling in, I remind myself of that. This is a gift. There is something glorious and beautiful in everything around us; we just need to look.

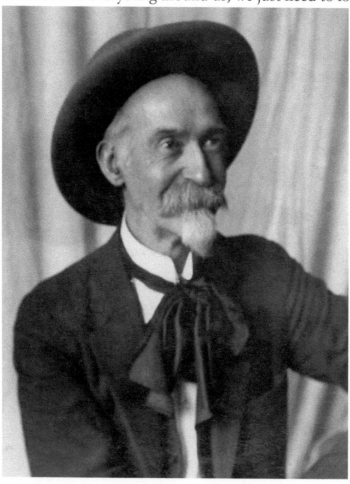

GALLERY OF WORK

The following pages include a sample of Merton Clivette's art. It's impossible to know how many paintings, drawings, sculptures, and other pieces of art Clivette created during his lifetime but know that this is a mere sampling of the thousands that we do know of.

Indian Seascape, ca 1925

Seascape Vertical 109, ca 1925

Seascape Calm 155, ca 1925

Indian Seascape 104, ca 1925

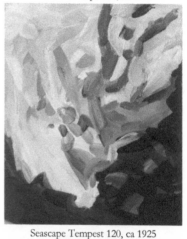

Seascape Vertical, ca 1925

Seascape Tempest 120, ca 1925

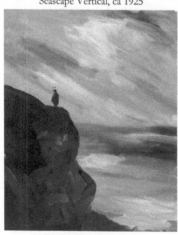

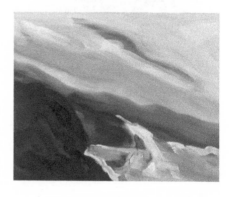

Indian Seascape 106, ca 1925

Seascape Tempest 142, ca 1925

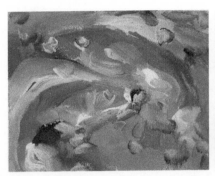

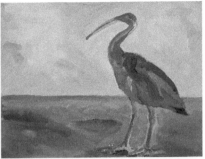

Group Fish, ca 1925

Pelican, ca 1920

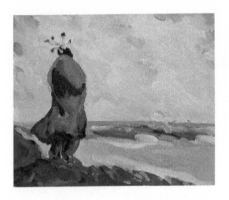

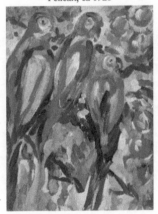

Indian Seascape, ca 1925

Parrots, ca 1920

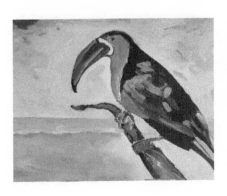

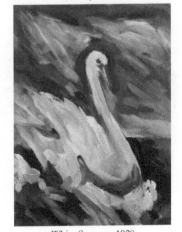

Toucan, ca 1920

White Swan, ca 1920

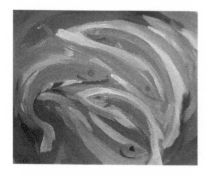

Group Fish 133, ca 1925

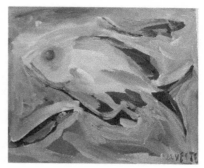

Single Fish 113, ca 1925

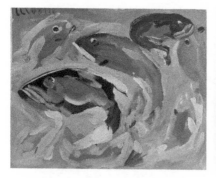

Group Fish 117, ca 1925

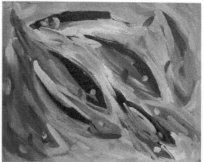

Group Fish 138, ca 1925

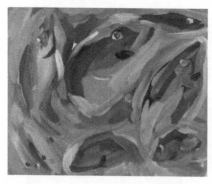

Group Fish 165, ca 1925

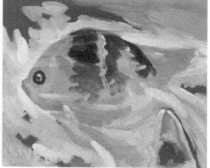

Single Fish 116, ca 1925

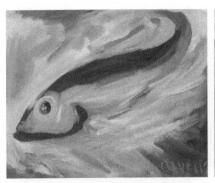
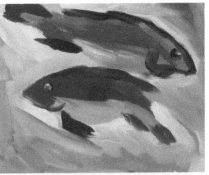

Single Fish 119, ca 1925

Group Fish 160, ca 1925

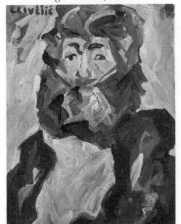
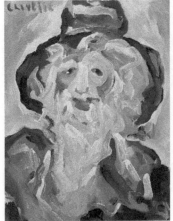

Portrait Male, ca 1920

Portrait Male, ca 1920

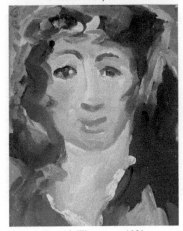

Portrait Woman, ca 1920

Portrait Male 102, ca 1925

Portrait Male 107, ca 1925

Portrait Woman 141, ca 1925

Portrait Woman 151, ca 1925

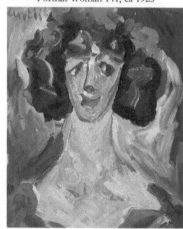

Portrait Woman, ca 1920

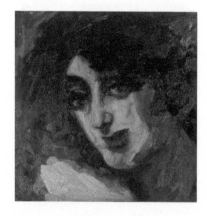

Vamp #51, ca 1920

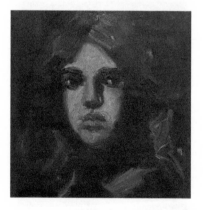

Vamp #4, ca 1920

EPILOGUE: FACT FROM FICTION
(FROM THE AUTHOR)

A few year prior to beginning this project, I got in the habit of reading today's newspaper from one hundred years ago. I didn't read it from start to finish, but I'd often read twenty to thirty articles to see what was happening a century ago. I've always found the twenties to be an interesting period of United States' history, and thought I was pretty familiar with what was happening on a macro level, but looking at it on a daily basis was illuminating. For example: who knew there were so many bandits?

My doctoral work was focused on the period of 1782-1851, but my true passion was 1880-1920. In part, this was driven by the research that went into my Master's thesis which focused on Mark Twain. However, I also found that going back one hundred years (or a little more) there was a weird resonance that echoed through time that connected with me. Bandits aside, the events and struggles of the 1890s weren't so different from the 1990s and the turn of the century—whether in 1900 or 2000—similarly mirrored one another. The more connections I found, the more engrossed I became in reading newspapers from one hundred years ago.

One day, May 12, 2022, I read a headline that really captured

my attention.

"Vandal Shoots Through Window of Artist at Wilson's Picture."

I was reading the articles in a database collection, and so there were articles from all kinds of newspapers jumbled together. This one happened to be from the *Louisville Courier Journal*. I reprint the article below, with permission from the newspaper:

"New York, May 11. 'Salome,' a painting of the head of ex-President Wilson which caused considerable comment at an exhibition of the Society of Independent Artists at the Waldorf Astoria Hotel last March has apparently been misunderstood in Greenwich Village. For several weeks the picture has been displayed in a window of the Art Mecca Shop, 1 Sheridan Square. Early last evening Merton Clivette, the artist and proprietor of the shop, heard a shot. He hurried to the street too late to see anyone, but noticed that the window had been shattered by a bullet. It struck the window just in front of the picture, but did not penetrate it. "Mr. Clivette said the painting is the most misunderstood of any that has ever been exhibited. It depicts the head effect of ex-President Wilson on a tray lifted by a muscular black hand and arm. Surrounding the tray is pictured the waves of a turbulent sea, representing the trouble condition of the world. It was painted in 1916 and is valued at over $10,000, according to Mr. Clivette. 'A person who would fire at a painting of ex-President Wilson would shoot our former President if he got the chance,' said Mr. Clivette. To the side of the picture was this statement: 'for three weeks at the Waldorf-Astoria this picture was viewed by 10,000 people. Not one got it—showing the decrepit brains that wander about in the musty skulls of the degenerate populace, the pick of America. As paint critics they mingle with the mutes of the mongrel. Here in all seriousness did the artist, Merton Clivette, depict the head of an idealist. Woodrow Wilson, who though: with the precision of a God and so expressed himself and the dumb public demanded his head, as they did before the head of John the Baptist—a just man howling in the wilderness. Ex-President Wilson will go down to a later and wiser generation as 'Statesman of the World.' Then perhaps the showing of his head, on a Chinese gong by a blackhand of commercialism will show they the present world is at sea.'"

My first thought was: I need to see that painting.

Without bragging, I'm a decent researcher. Between the

various databases and internet searches, I can typically find anything I want, and it's a little baffling when I come up blank. But that was the case here. I could not find the painting, or any other reference to it, despite the fact that it *"caused considerable comment"* in March 1921. I found all variety of information about the exhibition at the Waldorf Astoria—including the list of paintings exhibited and which artist produced each work—but there was no mention of a painting called "Salome." There were other paintings by Clivette, and they were striking, but nothing matched the description from the article.

In my searches, I did come across clivette.com, and I used the "contact us" form to ask if they had any additional information about the painting, or this particular story. Admittedly, I had little expectation of receiving a reply. That kind of form is often a blackhole. But, a few days later, there was a reply. After a bit of a back and forth, I learned I was chatting with the nephews of Clivette's lone grandson. Sadly, they had no additional information about the painting.

I kept looking into Clivette and found he was strangely connected to everything in the entertainment world. Eventually, I expressed interest in writing a biography about him, because— shockingly—none had been written. The family was interested and offered to share their substantial archive with me.

So, this book was born. A collaboration, I'm sure, Clivette himself would have loved.

As with any attempt at recreating history, there are holes and things we simply cannot know. Clivette did a much better than usual job of keeping records, notes, ledgers, letters, newspaper clippings, and the like from his life. Much of my job was to take the existing information, knit them together, and put together plausible connective tissue. Let me address some of the more seemingly outlandish claims here and provide a little fact or fiction.

All the information about Clivette's early life—growing up in Wisconsin, his father's death, his mother moving them to Wyoming and working at a newspaper, Clivette running away to

join the circus—is documented and verifiable. He also most definitely joined the Wild West Show.

Which circus did he join? And did he join the Wild West Show first, or the circus first? These are things I struggled to confirm. Ultimately, when I looked at his journals and ledgers and the dates of the circus and the dates of the Wild West Show, the Wild West Show lined up neater with the facts than the circus did. Furthermore, I imagined the things he would have learned in the Wild West Show would have served Clivette well in the circus, but maybe not vice versa. As a young boy, adept at riding a horse, I could see him fitting in, in costume in the Wild West Show. We don't know that he met Cody, but from what I've read about Cody during that period of his life, Cody liked to know everyone in the troop. He was a bit of a micromanager, and so it seemed likely that that the two of them would have met and chatted. And if they met and chatted, even more likely they would have bonded over a shared history. The parallels between Cody's early life and Clivette's echoed one another.

There were many circuses operating at the time Clivette was performing in the Wild West Show, but none were bigger than Barnum's. Taylor had an eye for talent, and since we know that Clivette later manipulated facts to make a more compelling story about himself, it seems logical that he would have learned from the best showman and fact-manipulator of them all.

Did Clivette meet Mark Twain? The family story was that Clivette was the basis of Twain's character "the Mysterious Stranger" in the novel that Twain was working at towards the end of his life. As a Mark Twain scholar, I was dubious but curious. It's true that Twain loved and was fascinated by the circus and the Wild West Show, and he loved vaudeville, minstrel shows, spiritualism, magic, and mindreaders. He didn't necessarily believe in all of it, but he didn't necessarily not believe either. Since Clivette did all these things, performed during the time Twain was known to be attending these shows, it seems very likely that Twain would have met him. Like Clivette, Twain kept notes and letters and was remarkably connected to everyone who

was anyone. Twain frequently went to the Wild West Show, circuses, vaudeville shows, shadowgraphy shows, and enjoyed magicians and mediums perform throughout his life—but mostly from 1880-1910, the peak times that Clivette was performing. Twain knew Barnum and Cody, wrote them letters and dined with them. As an extremely curious man, I can't imagine there being someone of Clivette's diverse abilities and Twain not having met him. And, if you ever read *The Mysterious Stranger*, you'll find the character does resemble Clivette. Almost eerily. Twain started writing it around 1897—when Clivette would have been ending his run on the Orpheum Circuit and in his prime as a magician. Ultimately, Twain didn't finish this novel in his lifetime, but he kept picking away at it, and there are several different drafts that exist. The consistent piece of the story is a character with magical powers—sometimes called No. 44, sometimes Satan, sometimes "the stranger"—who takes other characters on a magical journey and forces them to confront the world around them in a new way. The character challenges them to question the things they take for granted and ultimately waxes philosophically, much as Clivette does in the books he published.

What about Arthur Conan Doyle? The story about Doyle is referenced in several interviews during Clivette's lifetime and in a couple of the obituaries that ran after his passing. Houdini knew Doyle well, and it's well documented that Houdini often worked to convince Doyle that he truly had no magical powers. Houdini was also on the Orpheum Circuit and joined after Clivette was already a staple. As headliners, it would be unheard of them not knowing one another. How well they knew one another is difficult to say.

Clivette did study under Rodin—who apparently thought Clivette's painting of him was the best likeness ever created. He also studied under William Merritt Chase, John La Farge, John Henry Twachtman. These were all referenced in articles during Clivette's lifetime and again in obituaries. The precise dates of when he studied with them is harder to verify, but it's easy to imagine how it might have fit into the holes in his touring

schedule.

Perhaps the hardest part of reconstructing Clivette's life was in untangling the exaggerations and propaganda generated to inspire interest and sell tickets.

When Clivette died in 1931, the truth started coming together. Instead of being born 1848 on the *S.S. Enterprise* in the middle of the Indian Ocean, we learn he was born in Portage, Wisconsin in 1868. Instead of being "forty years" his wife's senior, he was two years older than Catherine. Advertisements announcing his art shows claimed Clivette was 78 or 79 years old (in 1926 and 1927), an octogenarian (in 1929), but when he passed, nearly every obituary recorded his age correctly. In preparation for death, Clivette seems to have set the record straight. Many of the obituaries included language like, *"To the surprise of many, Clivette was only 62 years of age."* Even at sixty-two, Clivette was a specimen of impeccable fitness, but like many other claims he made during his career, the exaggeration was more notable than the truth.

The truth of Clivette's life was nearly as fascinating as the larger-than-life personae he adopted as a showman. In addition to knowing all the famous people I already addressed, he was, by all accounts, a remarkably gifted magician, illusionist, equilibrist, slack- and tight- rope walker, juggler, shadowgraphist, silhouettist, phrenologist, lecturer, and pantomimist. He did travel the world, at least to Europe, England, India, Cuba, China, Australia, and Canada, and crossed the Atlantic multiple times. Clivette did write and publish books (whether they were as great as he claimed or how many he claimed to have written is up for debate).

His artwork was controversial at times, which was in keeping with Clivette's self-promotion, self-aggrandizing from his show business days. But, it was popular and well-received—with a few notable exceptions, primarily in California. He sold many paintings during his lifetime and achieved the rare feat of being alive to enjoy the attention of his fame. His paintings are proto-abstract-expressionist that laid the groundwork for Jackson Pollock and Willem de Kooning, Franz Kline, and Mark Rothko.

I truly believe his artworks are underappreciated and undervalued, and I'd love to see them restored to the walls of museums alongside his contemporaries and the artists clearly inspired by his work.

Clivette also brought character to Greenwich Village and established a community of artists, creatives, and thinkers that persisted after his passing. However controversial a person he may have been, he also was a unifying force that brought people together and inspired community.

And yet, despite all the flash and spectacle of his life and the impact he had, somehow, he has slipped through the cracks of the history and art history books alike. When he is mentioned, it's a passing reference, a paragraph, a photograph of a painting, but never any additional context or attempt to document this man's life. Clivette's friend and art patron, George Sidney Hellman (1888-1958), said he was going to write Clivette's biography, but it was too soon after Clivette's passing. Then the project seemed to be forgotten. Now, with the archive and help from the Clivette Estate, all these years later, approaching the 100th anniversary of his death, this is an attempt to set the record straight. To document Clivette in his fantastic truth.

BIBLIOGRAPHY

Despite my best efforts, this is likely an incomplete list. There were many sources that I consulted to make sure the timeline worked, and some I likely didn't record. Some only included mere mentions of an art exhibit and a date, others were a poster or flyer of a performance. There were even more documents, primary documents that Clivette himself wrote or drew, or photographs, that I didn't record because they didn't have a formal publisher or method to really indicate what the document was or where you could find it. The surviving family was very generous with their archives, and I am extremely grateful for the access they granted. As it is a family archive, and not a formal academic one, there's no direct path to citation. I've done my very best to be as complete and accurate as I could. Should you have any questions about where a piece of information was obtained, feel free to reach out. I'll do my best to track it down and respond.

Books:

Barnum, P.T. *Barnum's Own Story: The Autobiography of P.T. Barnum.* Dover Publications: 2017.

Bowdoin, W. G. "The Man in Black, Eternalist, Makes a Village Exhibit." *The New York Evening World.* 17 September 1919.

Buffalo Bill Museum and Grave. *Did Buffalo Bill Visit Your Town? A Comprehensive Country/State Listing of William "Buffalo Bill"*

Cody's Tour Destinations. 2010.

Buffalo Bill. *Buffalo Bill's Life Story: An Autobiography*. Skyhorse: 2010

Buffalo Bill. *Buffalo Bill's Wild West: Historical Sketches and Daily Review*. Cincinnati: Strobridge Litho. Co., 1907.

Clivette. *A Bouquet of Worse Liver*. Chicago, Laird & Lee: 1908.

Clivette. *A Tome of Liver Worse*. Chicago, Laird & Lee: 1909.

Clivette. *Café Cackle from Dumps to Delmonicos'*. Chicago, Laird & Lee: 1909.

Clivette. *Confessions of a Palmist*. Chicago, Laird & Lee: 1908.

Clivette. *It*. Sign of the Sphinx, New York, Nine Barrow Street: 1922.

Clivette. *The Red Rag*. Chicago, Laird & Lee: 1907.

Clivette. *Thorn Decked Prince of Peace*. Chicago, Laird & Lee: 1917.

Copperfield, David, Wiseman, Richard, and David Britland. *David Copperfield's History of Magic*. Simon & Schuster: 2021.

Daniel, Noel, Caveney, Mike, Jay, Ricky, and Jim Steinmeyer. *Magic: 1400s-1950s*. Taschen: 2009.

Delaney, Michelle and Gertrude Kasebier. *Buffalo Bill's Wild West Warriors: A Photographic History*. Harper Collins: 2007.

From the Ralph Pulitzer Estate and others. *Paintings, Watercolors, Drawings, Sculptures*. Plaza Art Galleries, Inc: New York: 6 February 1941.

Jay, Ricky. *Jay's Journal of Anomalies: Conjurers, Cheats, Hustlers, Hoaxsters, Pranksters, Jokesters, Impostors, Pretenders, Sideshow Showmen, Armless Calligraphers, Mechanical Marvels, Popular Entertainments*. Farrar, Straus, Giroux: 2001.

Jay, Ricky. *Learned Pigs & Fireproof Women*. Farrar Straus & Giroux; 1986.

Kalush, William and Larry Sloman. *The Secret Life of Houdini*. Atria: 2007.

Kasson, Joy S. *Buffalo Bill's Wild West: Celebrity, Memory, and Popular History*. Hill and Wang, 2001.

LaDelle, Frederic. *A Complete Illustrated Course of Instruction How to Enter Vaudeville*. CreateSpace: 2016.

Lamont, Peter and Jim Steinmeyer. *The Secret History of Magic: The*

True Story of the Deceptive Art. TarcherPerigee: 2018

Lewis, Robert. *From Traveling Show to Vaudeville.* John Hopkins University Press: 2007.

Little, George H and Lawrence. *The Vaudeville.* 1895.

Little, George H and Merton Clivette. *Artist Era.* 1896.

Little, George H. *Mahatma.* 1895-1906.

Lorenz, Marianne. *Theme & Improvisation: Kandinsky & the American Avant-garde, 1912-1950.* Little, Brown: 1992. 157-158.

Lustig, David J. *La Vellma's Vaudeville Budget: For Magicians, Mind Readers, and Ventriloquists.* Robert W. Doidge: 1926.

Mellow, James R. *Walker Evans.* Basic Books: 1999.

Merton Clivette Papers, 1927-1930. Archives of American Art, Smithsonian Institution.

Miller, Edwin Haviland. *The Artistic Legacy of Walt Whitman, A Tribute to Gay Wilson Allen.* New York University Press: 1970.

Modern Art Paintings Watercolors Drawings: From the Collections of Paul Reinhardt, Miss Edith Wetmore, and Mrs. Charles Howland Russell, Jr. and Others. Edward P and William H. O'Reilly. 7 May 1939.

Monod, David. *Vaudeville and the Making of Modern Entertainment, 1890-1925.* North Carolina University Press, 2020.

Mulholland, John. *John Mulholland's Story of Magic.* Racehorse: 2019.

Museums of The Brooklyn Institute of Arts and Sciences. *Report for the Year 1930.* 1931.

Poore, Henry Rankin. *Modern Art: Why, What and How?* Knickbocker Press: 1931.

Rains Galleries including a Collection of Art of the Moderns. *Rains Auction Rooms.* 13 May 1937.

Ringling, Bros. *Route of Ringling Bros. Shows: 1882-1900.* Central Printing and Engraving Co: 1902.

Slide, Anthony. *The Encyclopedia of Vaudeville.* University Press of Mississippi: 2012

Society of Independent Artists. *11th Annual Exhibition of the Society*

of Independent Artists. New York, N.Y.: 1927.

Standiford, Les. *Battle for the Big Top: P.T. Barnum, James Bailey, John Ringling, and the Death-Defying Saga of the American Circus.* PublicAffairs, 2021.

Stein, Charles W. *American Vaudeville as Seen by its Contemporaries.* Da Capo Press: 1985.

Steinmeyer, Jim. *The Last Greatest Magician in the World: Howard Thurston Versus Houdini & the Battles of the American Wizards.* TarcherPerigee: 2012

Stewart, D. Travis. *No Applause Just Throw Money: The book that made Vaudeville Famous.* Faber & Faber: 2006.

Twain, Mark. *No. 44 The Mysterious Stranger.* University of California Press: 2011.

Warren, Louis S. *Buffalo Bill's America: William Cody and The Wild West Show.* Vintage: 2006.

Wertheim, Arthur Frank. *Vaudeville Wars: How the Keith-Albee and Orpheum Circuits Controlled the Big Time and its Performers.* Palgrave Macmillan: 2009.

Wilson, R. L. and Greg Martin. *Buffalo Bill's Wild West: An American Legend.* Random House: 1998.

Wilson, Robert. *Barnum: An American Life.* Simon & Schuster: 2019.

Newspapers and Magazines:

"A Clivette Exhibition." *The Art Digest.* 15 April 1933. p. 10.

"A Little Bit of Paris in Little Old New York." *Sunday News.* 16 July 1922. p. 24.

"A Painter of Vamps--Tooting in the New Year." *American Pictorial.* 2 January 1922.

"A Queer, Unusual Personality is Clivette." *The Detroit News.* 16 December 1928.

"A Show of Works by the American Painter: Clivette." *L'Art Vivant Bernheim-Jeune.* 16 July 1927.

"A Very Good Slack Wire Performer named Clivette." *Albany Democrat-Herald.* 11 September 1888. p. 3.

"Ainslee Opens with Clivette." *The Detroit News.* 16 December

1928.

"Ainslie Enters Detroit Field." *The Art Digest*. Mid-December 1928. p. 8.

"Ainslie Galleries, Open in Detroit." *The Art News*. 1 December 1928. p. 26.

"Ainslie Sponsors Clivette." *The Art Digest*. Mid-November 1928. p. 6.

"American Art and the Museum." *The Bulletin of the Museum of Modern Art*. November 1940. pp. 3-26.

"Amusements." *Chicago Daily Tribune*. 8 October 1896. p. 6.

"An Exhibition at Goodwater Grove." *The Stockton Mail*. 4 May 1886. p. 3.

"Around the New York Galleries: Work by Several Artists including Merton Clivette, Schenke, Boardman, Robinson, Lemordant, Pye, Czobel and Others." *The New York Times*. 23 January 1927. p. 10.

"Art and Artists.: Painting and Sculpture." *Los Angeles Times*. 26 November 1928.

"Art Man. " *Time*. 24 January 1927. p. 19.

"Art: Exhibitions of Paintings." *The New York Times*. 20 February 1921. p. X7.

"Art: Exhibitions of Paintings." *The New York Times*. 8 May 1921. p. 79.

"Art: Hellman Paintings on View." *The New York Times*. 11 December 1932. p. 35.

"Art: News of Exhibits Current in Gotham." *Chicago Daily Tribune*. 30 January 1927. p. G4.

"Art: The Last Days of Winter Exhibitions." *The New York Times*. 26 February 1922. p. 79.

"Artist Requests Ashes be Scattered to Four Winds." *The Buffalo Courier Express*. 10 May 1931.

"Artist Wins Fame after 70-Year Bid." *New York Evening Post*. 15 January 1927.

"Asks Governor to Extend Quiz of Courts Here: Mrs. Clivette goes over Head of Appellate Division with Plea." *The Brooklyn Daily Eagle*. 21 January 1931. p. 1.

"At the Temple, M Clivette." *Sentinel-Democrat.* 26 October 1897.

"Big Apartment for Sheridan Square." *The New York Times.* 19 August 1923. p. RE1.

"Brisk Spectacle at Hippodrome." *The New York Times.* 1 September 1912. p. 9.

Burgess, Clinton. "Metropolitan Magic." *The Billboard.* 31 July 1920. p. 51.

Burrows, Carlyle. "News and Exhibitions of the Week in Art." *New York Herald Tribune.* 24 November 1929.

"California Raises the Question of Clivette." *The Art Digest.* Mid-February 1929. p. 8.

"Cincinnati Show." *The Art Digest.* 1 March 1927. p. 8.

Clifton, Leigh Ann. "Merton Clivette at Couturier." *Art & Auction.* October 1993.

"Clivette Again." *The Art Digest.* Mid-December 1927. p. 9.

"Clivette Arrives with a Boomity Boom." *The Art Digest.* 1 February 1927.

"Clivette at Vassar." *The Art Digest.* 15 February 1927. p. 20.

"Clivette in Paris." *The Art Digest.* August 1927. p. 2.

"Clivette is Dead." *The Art Digest.* 15 May 1931. p. 7.

Clivette, Merton. "Winning the 'Type-Sticking' Race in Old 'Frisco." *The Country Editor.* Rockville Center, Long Island, NY: November 1922.

"Clivette Paintings now on Exhibition." *New York Enquirer.* 2 April 1933.

"Clivette Petition Plan Gets Backing." *The Brooklyn Daily Eagle.* 20 January 1931. p. 3.

"Clivette The Eternalist." *Los Angeles Times.* 30 August 1931. p. B14.

"Clivette the Incomparable Breaks Summer Art Drought." *Brooklyn Daily Times.* 17 August 1930. p. 9A.

"Clivette, the Main in Black." *Alton Evening Telegraph.* 27 October 1897.

"Clivette, World's Greatest Artist, by his own Admission, Quits Village for Paris." *The Evening Telegraph.* 13 March 1923.

"Clivette." *The Art Digest.* 15 March 1927. p. 6.

"Clivette." *The Art Digest.* Mid-October 1930. pp. 9, 18.

"Clivette: At the Temple, Wednesday and Thursday." *The Carlinville Daily.* 25 October 1897.

"Clivette's Pictures." *The Art Digest.* 15 October 1932. p. 8.

"Contemporary Artists' Work Exhibited Here." *The Philadelphia Inquirer.* 27 December 1942. p. a7.

Cravens, Junius. "The Clivette Invasion." *Argonaut Magazine.* February 1929.

"Creative Spirit at Arts Council." *The Art News.* 28 January 1927. p. 8.

"Cubists, Otherists all in Art Show." *New York World.* 13 March 1927.

"Deaths." *The New York Times.* 12 May 1931. p. 23.

"Entertainment at the Cafe Monico." *Pall Mall Gazette.* 20 April 1895.

Estcourt, Charles Jr. "New York Skylines." *The Courier-Journal, Louisville.* 5 February 1928. p. 8.

"Exhibition in Paris." *The New York Times.* 24 July 1927.

"Exhibition of Watercolor Paintings, Pastels and Drawings by American and European Artists and Miniatures by the Brooklyn Society of Miniature painters." *Brooklyn Museum.* Brooklyn, N.Y.: 1929.

"Exposition D'Oeuvres du Peintre American Clivette." *Chez Bernheim-Jeune Editeures D'Art.* Paris, France: 1927.

"Extravagant?" *The Art Digest.* September 1930. p. 11.

Fietelson, Lorser. "Two New Canvases by Clivette at Palace." *Oakland Tribune.* 19 February 1928.

Flint, Ralph. "Art News and Comment: New York Exhibitions." *The Christian Science Monitor.* 31 December 1927.

Frank, Stanley. "Anything goes in Greenwich Village." *Saturday Evening Post.* 16 September 1950. pp. 127-132.

"Free Exhibition of Gustave Nassauer's Collection of Paintings by Clivette." *Art Center.* New York, N.Y.: 1929.

"Greenwich Village Historical Society to Exhibit at Ainslie's." *The Art News.* 1 December 1923. p. 5.

Harris, Ruth Green. "Now on Exhibition in Paris." *The New York*

Times. 24 July 1927.

"Here is the way to make clever shadow pictures." *San Francisco Call.* 5 June 1898. p. 5.

"High Art Calls Cop when Critics Carp." *The Sun.* 29 January 1919. p. 6.

"Hopkin's Vaudeville." *The Courier-Journal, Louisville.* 28 September 1902. p. B2.

"Humorous." *The Courier-Journal, Louisville.* 6 March 1909. p. 5.

"In the Wake of the news: Earlier Chicago." *Chicago Daily Tribune.* 9 February 1929. p. 19.

"Joint Exhibition of Unusual Paintings by the Mystic, Poet-painter of the Unseen: Prince Childe de Rohna-d'Harcourt and Merton Clivette, Painter of the Mob." *The Spanish Society.* 3 June 1925

Kirsh, Francine. "Big Top Treasures." *Antiques & Collections.* 1999. pp. 53-57.

Lehre, Florence Wieben. "Feininger, Clivette and Others." *The Argus: A Journal of Art Criticism.* January 1929. p. 10.

Lehre, Florence Wieben. "Is Clivette and Artist or Faker?" *Oakland Tribune.* February 1929.

"Lincoln Nude." *Time.* 17 December 1928. p. 20.

"List of Accessions." *The Brooklyn Museum Quarterly.* January 1931. pp. 39-40.

"Made his Mark: The Oakland Painter who is known in the Theatrical World." *Oakland Tribune.* 7 February 1891. p. 5.

Mannes, Marya. "Gallery Notes." *Creative Art.* January 1928. p. 5.

"Many Attractions for Park Visitors." *The Courier-Journal, Louisville.* 6 July 1905. p. 2.

Mason, Richard. "Independent Artists Have Their Little Jokes at Free-for-All Exhibition." *Page Eleven.* 22 March 1925. p. 107.

McBride, Henry. "Clivette, the Impressionist, at the New Gallery." *New York Sun.* 15 January 1927.

McCormick, William B. "A Review." *Journal American.* 24 November 1929.

"McVicker's: Schiller." *Chicago Daily Tribune.* 16 May 1897. p. 34.

"Merton Clivette Estate $2,000." *The New York Times*. 26 June 1931. p. 15.

"Merton Clivette Eulogized by Sulzer: Ex-Governor Pays Tribute to Artist and Writer at Funeral Services." *The New York Times*. 10 May 1931. p. N7.

"Merton Clivette, Artist, Dies at 62." *The New York Times*. 9 May 1931. p. 13.

"Merton Clivette, The Man in Black." *California View Fine Arts*. Los Gatos, CA: 2004.

"Merton Clivette." *New York Evening Post*. 15 January 1927.

"Merton Clivette." *The Art News*. 23 May 1931. p. 14.

"Merton Clivette: New Gallery." *The Art News*. 24 December 1927. p. 10.

"Merton Clivette: New Gallery." *The Art News*. 29 December 1927. p. 11.

Millier, Arthur. "Brush Strokes." *Los Angeles Times*. 9 June 1935.

Moore, Frank. "On the West Coast." *The American Magazine of Art*. December 1927. pp. 675-677.

"More Studios for Sheridan Square." *The New York Times*. 31 October 1926. p. RE2.

"Mrs. C. P. Clivette, Civic Leader Here: Founder of Greenwich Village Historical Society, Former Singer and Actress, Dies." *The New York Times*. 23 June 1951. p. 15.

"Mrs. C. P. Clivette." *The Art Digest*. 1 July 1951. p. 29.

"Mrs. Clivette Honored." *The New York Times*. 28 June 1931. p. 22.

"Mrs. Merton Clivette Quotes Ainslie's Daughter at Trial of Atalie Rider." *The New York Times*. 14 November 1924. p. 15.

"Music and Drama: Attractions of the Week." *Chicago Daily Tribune*. 3 September 1899. p. 36.

"Nassauer Declares Clivette Is Greatest Artist of All the Ages." *The Art Digest*. Mid-October 1930. p. 9.

"New Books of the Spring Season." *The New York Times*. 10 April 1909. p. BR222.

"News from the Dailies: New York." *Variety*. 19 January 1927. p.

35.

"Not Yet Writing Clivette Biography." *The New York Times*. 15 May 1931. p. 48.

"Notable Paintings & Drawings Chiefly of the Modern School." *American Art Association*. New York, N.Y.: 1932.

"Notes on Current Art." *The New York Times*. 2 May 1920. p. X10.

"Oakland Debunks Clivette." *Argus Magazine*. February 1929.

"Obituary: Merton Clivette." *Variety*. 13 May 1931. p. 93.

"Old Masters and Ex-Magician Share Attention in First Collection Shown." *The Detroit Free Press*. 16 December 1928.

"Painter Clivette hailed as Wonder." *New York Sun*. 2 May 1927.

"Paintings & Sculptures by Living Americans." *Museum of Modern Art & Plandome Press*. New York, N.Y.: 1930.

"Playbills." *Chicago Daily Tribune*. 13 September 1903. p. 37.

"Playbills." *Chicago Daily Tribune*. 14 June 1903. p. 37.

"Portraits of Artists are Presented in a Special Exhibition." *The Art Digest*. 1 November 1932. p. 32.

"Portraits of Artists—Roerich Museum, New York." *The American Magazine of Art*. November 1932. pp. 293-294.

"Prefers Kreisel to Sheeler." *The Art Digest*. 15 October 1939. p. 15.

"Propagandists Dwarf Real Painters at the Independents' Annual." *The Art Digest*. 1 May 1936. p. 7.

"Recent Deaths and Memorials." *Science, New Series*. 13 November 1936. pp. 433-434.

"Recent Museum Acquisitions." *Parnassus*. October 1929. pp. 20-21.

"Rites for Clivette, Artist, Conducted." *Brooklyn Daily Eagle*. 18 May 1931. p. A14.

Roach, George. "Notes and Comments." *New York History*. July 1942. pp. 368-388.

"San Francisco." *The Art News*. 2 February 1929. p. 24.

"Scientific Notes and News." *Science, New Series*. 13 November 1936. pp. 434-436.

"Scientific Notes and News." *Science, New Series*. 7 June 1935. pp.

555-559.

Semons, Lillian. "Merton Clivette." *Brooklyn Daily Times, Review.* 17 August 1930.

Smith, Louis W. "Clivette, Mysterious Man in Black." *The New York Times.* 17 July 1927.

"Spring Salon 1929." *Salons of America, Inc.* New York, N.Y.: 1929.

Stein, Aaron Marc. "Art's Circus Man Holds Show at 84." The *New York Evening Post.* 4 September 1930.

"Summertime Amusements." *The New York Times.* 22 June 1913. p. x9.

"The Ainslie Galleries of New York, Philadelphia, and Los Angeles opened in Detroit on December 15th in Three Galleries in the Fisher Building." *The Art News.* 22 December 1928.

"The Art Calendar." *The Art World.* 16 January 1927. p. 33.

"The Drama: Attractions for the Week." *Chicago Daily Tribune.* 18 September 1898. p. 36.

"The Sidelights of New York." *The Saratogian.* 29 April 1927. p 4.

"The Week in New York: Recent Openings Reviewed." *The New York Times.* 1 May 1932. p. X8.

"The Week's Novelties." *The New York Times.* 7 January 1906. p. 4.

"Theatrical Gossip." *The New York Times.* 25 September 1895. p. 8.

"To California: $33 one-way tickets on sale daily." *Chicago Daily Tribune.* 4 September 1905. p. 2.

"To Construct Community Center." *American Lumberman.* 6 June 1931. p. 44.

"To the Editor of *The Art Digest.*" *The Art Digest.* 15 October 1930. pp. 179-180.

"Unusual Pictures Appear in Hellman Auction." *The Art Digest.* 1 December 1932. p. 16.

"Utica Library to Exhibit Paintings by M. Clivette." *Utica Observer.* 26 November 1928.

"Vandal Shoots Through Window of Artist at Wilson's Picture." *The Courier-Journal, Louisville.* 12 May 1922. p. 13.

"Varied Art Shown at Modern Museum." *The New York Times.* 4 December 1930. p. 23.

"Vaudeville." *Chicago Daily Tribune.* 28 April 1907. p. I4.

"Vaudeville." *Chicago Daily Tribune.* 5 May 1907. p. I4.

"Village Vamps." *Mid-Week Pictorial.* 13 March 1924. p. 10.

Warner, Jeremy. "The World of Art." *Artists & Models Magazine.* May 1926. pp. 37-40.

"Week's Bills at the Theatres." *The New York Times.* 17 May 1910. p. 9.

"What is Going on this Week." *The New York Times.* 6 May 1934. p. N5.

"Who's Who in Art 1929." *American Art Annual.* 1929.

"World's Best Artist is Clivette! Ask Him!" *New York American.* 17 January 1927. p. 11.

"Zipp's Casino." *The Standard Union.* 22 March 1890. p. 5.

INDEX

E

F

G

H

I

J

K

L

M

N

O

P

Q

R

S

T

U

V

W

ABOUT THE AUTHOR

Originally from Michigan, Michael David MacBride now calls Minnesota home. Michael received his PhD in 19th century American and 18th century British Literature, but his true focus was 1870-1930. He studied Mark Twain and the period of American history from 1780-1930 and sought out the odd and unusual moments of history. Michael began his college career as an art student, then art history major and has continued to have a love for art and artists. For fun, Michael reads newspapers from 100 years ago--a habit he began in 2017 (which is how he initially became aware of Clivette). Michael taught English, Literature, and Humanities courses at universities and colleges in Minnesota, New Hampshire, Ohio, and Illinois, but also held a number of odd jobs. He has delivered newspapers, worked for UPS, delivered pizzas, did collections at a bank, was a roadie for a country band, and was a grant-writer and funder-researcher for non-profits. Regardless of what he was doing and when, the two consistent things in his life have been: writing and his intense curiosity. Michael has written academic books about pedagogy and cultural studies, non-fiction about LGBTIA+ history, contemporary "bookclub" fiction, speculative/science fiction, and a series of mid-grade interactive detective books.

ALSO BY MICHAEL DAVID MACBRIDE

Non-fiction:
- "How a Police Raid Shuttered a Haven for Gay Men." *The Advocate* (September/October 2022). p. 49.
- "The Original: Remembering John Sam Allen's political illustrations in the early days of *The Advocate*." *The Advocate* (March/April 2022). pp. 32-33.
- *"I'm Just a Comic Book Boy": Essays on the Intersection of Comics and Punk*
- *Tell Me a Story: Using Narratives to Break Down Barriers in Composition Courses*
- *Mobocracy: The Mob and American literature, 1780-1851*

Adult contemporary fiction:
- *The Life and Times of SKAborough Fair*
- *Lies from Beechwood Drive*
- *Voyager*
- *Emergency Preparedness and other stories*
- *Bidding Wars*

Midgrade interactive, detective fiction:
- *The Thompson Twins: Mystery at the Tournament*
- *The Thompson Twins: Mystery at the Zoo*
- *The Thompson Twins: Mystery at the Mansion*
- *The Thompson Twins: Mystery at the Comic Shop*
- *The Thompson Twins: Mystery at the Museum*